WEST COUNTRY TO WORLD'S END

The South West in the Tudor Age

Rovker beacon

Rouker downe

Broken crosse

10

11

Plimine

Shaue.

Bykel.

12

13

Warle

Conlestone.

Hendmill

Skittets house.

Great crosse.

14

Tamerton

15

16

Godeg shayde

Gorge.

Man- nin- ton.

17

Iohn to woods well.

Saltaish passage.

St Bodolfe

Pennie crosse

19

18

Hicke hockand

Deer mill p

War Lay

wick Heale

20

Penny crosse beacon

Comton.

Kentaber

21

24

Lypson hill

eggers lande.

23

25

The Maudlen

the way fro

Keame wile

22

the way from Saltaish to

26

PLIMMOUTH

woole

Stouke dambrel

stone house mills

the way to

27

the way from Plimouth to Plimstouk

Luf- ten- poole

cat dow

Stone- house

Plimouth mill.

The bea- con the Hooe.

Cremell passage.

The chap- pell.

Fishers nose.

Plym

Mylbroke

Mount Edgcombe

St Nicholas Iland.

How stert

Edg- combe

The Sounde.

WEST COUNTRY TO WORLD'S END

The South West in the Tudor Age

EDITED BY
Sam Smiles

WITH ESSAYS BY
Susan Flavin, Karen Hearn,
Stephanie Pratt and Sam Smiles

PAUL HOLBERTON PUBLISHING

First published to accompany the exhibition

WEST COUNTRY TO WORLD'S END
The South West in the Tudor Age

at the Royal Albert Memorial Museum & Art Gallery
26 October 2013 – 2 March 2014

ISBN 978 1 907372 52 0

British Library Cataloguing in Publication Data
A catalogue record for this book is available from the British Library

Produced by Paul Holberton publishing,
89 Borough High Street, London SE1 1NL
www.paul-holberton.net

Designed by Laura Parker
www.parkerinc.co.uk

Origination and printing by E-graphic, Verona, Italy

FOREWORD

This book accompanies an exhibition held at the Royal Albert Memorial Museum & Art Gallery, Exeter (RAMM), from 26 October 2013 to 2 March 2014. It draws together paintings, portrait miniatures, documents, books, medals, plasterwork, silver and woodwork that have a key connection with the south-west of England during the years between about 1530 and 1620.

The people of the South West are justly proud of their region's Tudor heritage. The names of Francis Drake, Walter Ralegh, Nicholas Hilliard and Thomas Bodley – players on the international stage who became icons of British history – are synonymous with a golden age for Devon. *West Country to World's End* is a celebration of these romantic figures and their feats; but the aim of the exhibition and publication is more than this alone. Our aim is to stress that the common origin of these men is not coincidental; they were born into a region of great intellectual and artistic wealth at a time of opportunity – a breeding ground for adventurers, merchants, scholars and artists.

The *West Country to World's End* project was initiated by Professor Sam Smiles and began with a thorough reassessment of sixteenth and early seventeenth-century archival records, focusing on Devon and the surrounding counties, in order to unearth evidence of patronage and artistic activity – taking a broad definition of the arts to include craftsmen in wood, plaster, lace, silver, stone and other media. This critical investigative work was undertaken by Susan Flavin over the course of 2010 and 2011 funded by The Paul Mellon Centre for Studies in British Art.

Work on identifying the loans for the exhibition began in 2012 led by Sam Smiles, Susan Flavin, Julien Parsons and Karen Hearn. It is thanks to the diligence and determination of these four individuals that such a wealth of treasures has come to Exeter. My sincere thanks are extended to the many institutions and private individuals who have kindly agreed to lend works for the exhibition.

Particular thanks are due to our funders: Exeter City Council, Arts Council England and The Paul Mellon Centre for Studies in British Art, who supported not only the research work but also the production of this wonderful volume.

Camilla Hampshire, Museums Manager
ROYAL ALBERT MEMORIAL MUSEUM & ART GALLERY

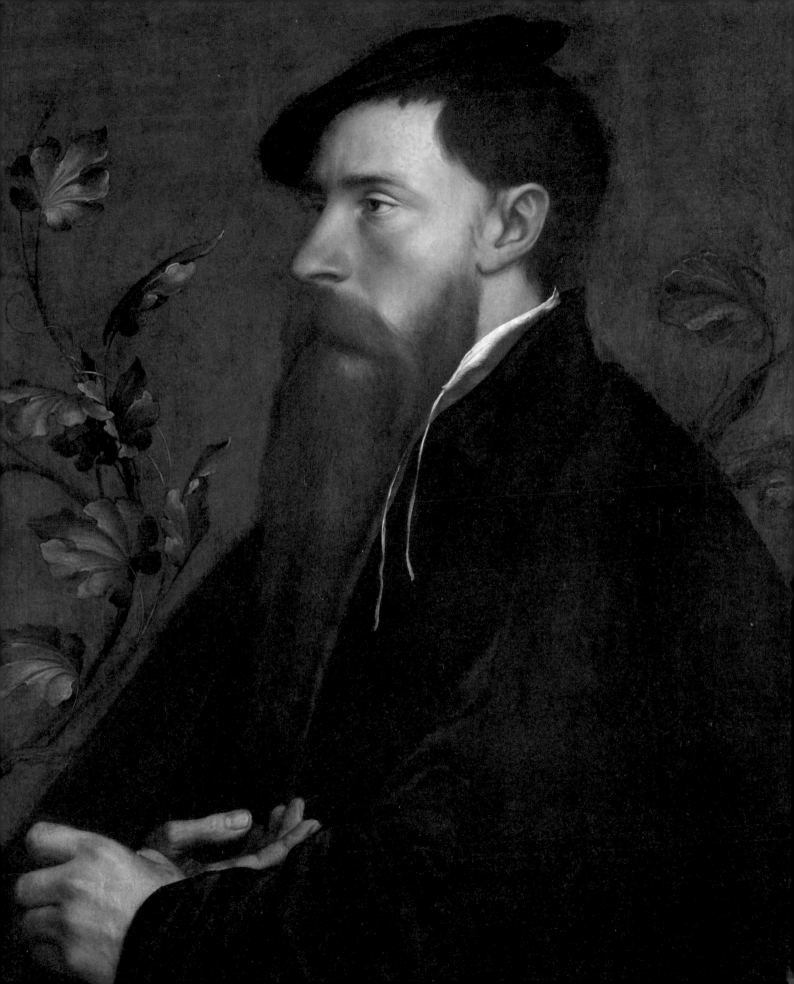

ACKNOWLEDGEMENTS

The Royal Albert Memorial Museum & Art Gallery gratefully acknowledges the support and assistance of the following individuals and institutions:

Sue Andrew, Peter Barber, Bruce Barker-Benfield, Ann Barwood, Sir Richard Carew-Pole, Chris Chapman, Hugo Chapman, Martin Clayton, Katie Coombs, Alison Cooper, Catriona Cornelius, James Daybell, Sandrine Decoux, Emma Denness, Jane Eade, Christine Faunch, Kevin Fewster, Jane Fisher, Susan Flavin, Liz Grant, Caroline de Guitant, Roxanna Hackett, Karen Hearn, Fiona Hearns, Paul Holberton, Gareth Hughes, Nick Humphrey, Renée Jackaman, Ellie Jones, Hannah Kauffman, Roly Keating, Peter Klinkenberg, Neil MacGregor, David McNeff, Louisa Mann, Jonathan Marsden, Theresa-Mary Morton, Nicola Moyle, Irena Murray, Carol Murrin, Sandy Nairne, Richard Ovenden, Laura Parker, Jeremy Pearson, Mary Peskett Smith, Stephanie Pratt, Christine Riding, Martin Roth, Justine Sambrook, Mike Sampson, Penny Sexton, Desmond Shawe-Taylor, Madeline Slaven, Kim Sloan, Sam Smiles, Christopher Stewart, Nick Stokes, Peter Thomas, Fernanda Torrente, Mark Tosdevin, William Tyrwhitt-Drake, Andrew Wallington-Smith, Harland Walshaw, Helen Whitcombe, Jane Whittle, Nigel Wiggins and Gareth Williams.

Antony House, Cornwall; Blundell's School, Tiverton; Bodleian Libraries, University of Oxford; The British Library; The British Museum; The Devon and Exeter Institution; Devon Heritage Services; National Maritime Museum, London; National Portrait Gallery, London; Exeter Cathedral Library; National Trust; The Paul Mellon Centre for Studies in British Art; Plymouth City Council (Arts and Heritage); private lenders; The Royal Collection Trust; Royal Institute of British Architects; Somerset Heritage Service; Tyrwhitt-Drake Collection; University of Exeter, Heritage Collections; Victoria and Albert Museum; The Weston Park Foundation; The Worshipful Society of Apothecaries of London.

The *West Country to World's End* exhibition would not have been possible without the hard work of the whole exhibition team and staff at RAMM. Additionally, this publication has benefitted from the input of Kate Loubser, Tom Cadbury, John Madin and Julien Parsons.

INTRODUCTION

Sam Smiles

IN 1581, ON THE OCCASION OF FRANCIS DRAKE receiving his knighthood at Deptford from Queen Elizabeth, the scholars of Winchester school wrote verses to celebrate his feat of circumnavigating the globe.

> *Sir Drake, whom well the world's ends knows*
> *Which thou dids't compasse round,*
> *And whom both poles of Heaven once saw,*
> *Which North and South doe bound;*
> *The starres above will make thee known,*
> *If men here silent were,*
> *The sunne himself cannot forget*
> *His fellow-traveller.*[1]

Drake's achievement had indeed carried him from the West Country to the ends of the earth, and the scholars' epigram has inspired the title of this exhibition: not, it should be said, to commemorate Drake alone, but as a pointer to the South West's manifold contribution to the Tudor age, in national and international contexts.

For understandable reasons, exhibitions about this period of history usually focus on London, with the provinces providing little more than a shadowy backdrop to the glittering world of the Court; but this leaves the everyday world of Tudor life beyond the capital somewhat unexamined and underplays the significance of individual regions. Together with the essays in this publication, this exhibition provides a different perspective, placing Tudor Devon and Cornwall in the spotlight and showing something of their cultural life, their connection with major historical events and the achievements of individuals born in the South West in warfare, exploration, trade, learning and the arts. The centre of attention is the period between the 1540s and the 1610s, which corresponds with the life of Exeter's most important artist, Nicholas Hilliard (c. 1547–1619), whose work provides such an important record of the key figures in Elizabethan society.

1

Abraham Gessner, The Drake Cup, c. 1595, silver gilt
© Plymouth City Council (Arts and Heritage)

2

Historical background

Although Henry VII had visited Exeter in 1497 to thank the city for its loyalty during Perkin Warbeck's rebellion,[2] no other Tudor monarch ventured into the South West. Yet the region was anything but insignificant in the Tudor era, not only as the birthplace of individuals whose several activities shaped Tudor society but also as a locality where internal and external threats to the realm needed to be combated.

Following the two Cornish rebellions of 1497, the next significant disturbance associated with the South West was the so-called Exeter Conspiracy of 1538, which saw Henry Courtenay, 1st Marquess of Exeter, found guilty of treason and executed. The administrative power Courtenay had wielded was transferred to Sir John Russell, who was made High Steward of Cornwall, Lord Warden of the Stannaries and President of the short-lived Council of the West (cat. 2). Henry VIII granted him the abbeys of Tavistock and Plympton, the wealthiest in Devon, as well as Dunkeswell Abbey and the Blackfriars in Exeter, which he converted into an opulent private residence.[3] In 1552 he was made Lord Lieutenant of Devon.

Henry's political isolation in Europe after the signing of a peace accord between France and Spain in 1538 led to fears of invasion. 'Device Forts' or 'Henrician Castles' were constructed along the southern coast of England, including the western harbours – most notably the impressive fortresses of St Mawes (1543) and Pendennis (1546), which defended Falmouth and Carrick Roads.[4] In Elizabeth's reign, in the wake of acts of piracy and privateering conducted by John Hawkins, Francis Drake and others from the 1560s onwards, hostilities with Spain placed Devon and Cornwall in the front line. As war threatened, Plymouth's St Nicholas's Island was heavily fortified in 1583–84. When Elizabeth signed the Treaty of Nonsuch in 1585, supporting the Dutch Protestant rebels of the United Provinces against Spanish rule in the Netherlands, Philip II of Spain took this as a declaration of war. The execution of his co-religionist Mary Queen of Scots in February 1587 helped decide him to invade England and restore it to Catholicism. Aware of Spanish intentions, Elizabeth's government made preparations. Sir Richard Grenville was given command of the defence of Devon and Cornwall in March 1587, and urgent messages passed between him and the Privy Council about the equipment, defences and state of readiness of the peninsula.[5] The story of the Armada in 1588 is too well known to be repeated here, but it should be remembered that its defeat was no knock-out blow (cat. 3). Indeed, two more invasion fleets sailed for Britain in 1596 and 1597,

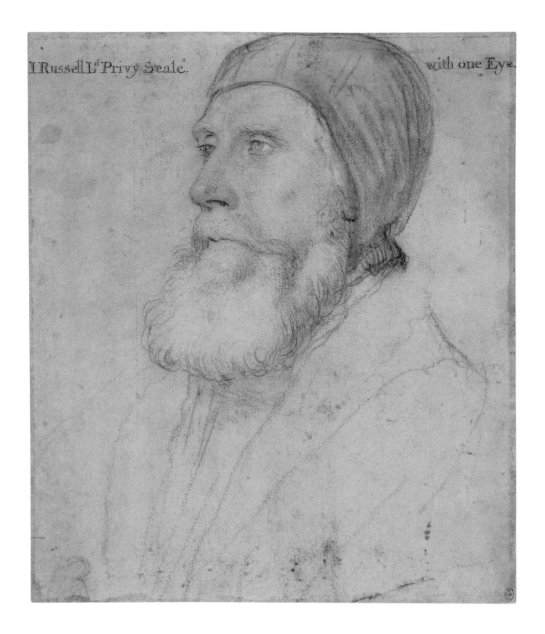

I Russell L. Privy Seale. with one Eye.

only to be beaten back by bad weather before mounting any sort of
threat. The fear of attack saw Plymouth heavily fortified in the 1590s,
but the long coastline of the peninsula was always vulnerable to assault.
Spanish troops were garrisoned in Brittany and in 1595 a small force
landed at Mousehole, Newlyn and Penzance and set them on fire.

Important as these events were, there is relatively little physical
evidence to show of them beyond the strengthened defences. Much
more profound for the culture of the region was the Reformation, which
transformed religious life in the South West. The smaller monasteries

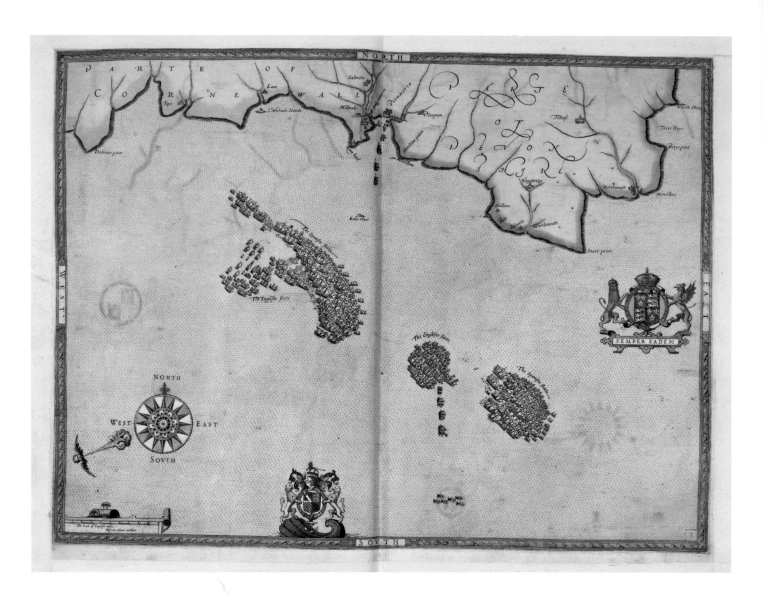

were suppressed in 1536, the larger ones in 1539, and the surrender of monastic buildings and estates was overseen by two natives of the region, John Tregonwell and William Petre. The impact of the subsequent changes in religious worship through the reigns of Edward VI, Mary I and Elizabeth I was felt in the smallest parish, and we know in some detail how one rural community reacted to these events from the account kept by Christopher Trychay, the priest of Morebath.[6] The Prayer Book Rebellion of 1549 broke out in the second year of Edward VI's reign, in response to the introduction of the Book of Common Prayer and church services in English, but fuelled by deeper economic grievances. Catholics from Cornwall and Devon besieged Exeter and

threatened a wider conflagration in the southern counties. Edward Seymour, 1st Duke of Somerset, sent Lord Russell to quell the revolt, which he did with great severity. His trained troops, including German and Italian mercenaries, defeated a peasant army in battles at Fenny Bridges, Woodbury, Clyst St Mary and Clyst Heath before overwhelming the survivors at Sampford Courtenay.[7]

While some Catholic loyalists of Devon and Cornwall went to their deaths opposing the Protestant Reformation, radical adherents of the new religion wanted it to go further. Puritan demands in the second half of the century threatened the Elizabethan Religious Settlement, legislated in the Act of Supremacy and the Act of Uniformity, passed in 1559. In the 1590s the theologian Richard Hooker, who was born and educated in Exeter, studied at Oxford and made his career in London, published *Of the Laws of Ecclesiastical Polity*, now regarded as one of the most important works of theological scholarship of its age and a foundational text for Anglicanism.[8] By articulating what should be the correct relationship between Scripture, religious authority and the governance of the Church, Hooker's work helped defend the legitimacy of the monarch as Supreme Governor of the Church of England.

Beyond doctrinal strife, the change in religious observance altered the very look of towns and villages as monasteries, priories and other religious buildings were put to other uses. Many of these confiscated properties were bought by gentry families. John Haydon, for example, made use of the stone from the suppressed College of Priests in nearby Ottery St Mary to build Cadhay Manor (*c.* 1550; fig. 1); the Champernownes acquired St Germans Priory in the 1540s and sold it to

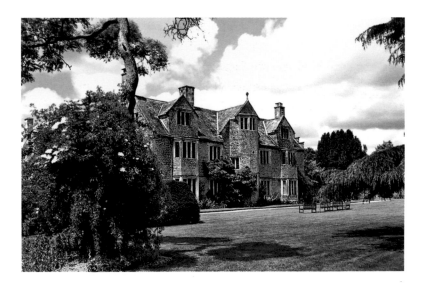

FIG. 1
Cadhay Manor, near Ottery St Mary, Devon, *c.* 1550 © Jody Barton / Cadhay House

FIG. 2
Holcombe Court, Holcombe
Rogus, *c.* 1540

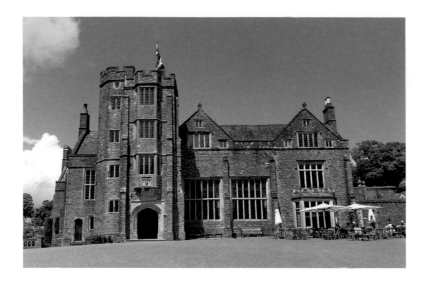

John Eliot in 1565, who developed it as Port Eliot; the Hurst family took possession of the living quarters of St Nicholas Priory in Exeter *c.* 1575, remodelling them as a town house; Buckland Abbey was converted into a family home by the Grenville family in the 1570s, some 30 years after they had acquired it, and was sold to Francis Drake in 1581; the abandoned Torre Abbey was refurbished for domestic use by the Ridgeway family after 1598.

Many of the most powerful names in the region developed their family seats. The two most distinguished surviving examples of purpose-built accommodation are Holcombe Court (fig. 2), Holcombe Rogus, built by Sir Roger Bluett (*c.* 1540) and the main E-plan range of Trerice, near Newquay, added by Sir John Arundell (*c.* 1570–73).

As these projects show, the South West was relatively unaffected by the taste that marked the Tudor era elsewhere in England for ambitious architecture, indebted to the new styles developing on the Continent. Richard Carew described the Cornish gentry as resistant to extravagance, preferring "liberall, but not costly builded or furnished houses".[9] Indeed, in both Devon and Cornwall modification and refurbishment of existing buildings was more usual than the erection of new houses, although the architectural record is distorted by the subsequent destruction or redevelopment of what were originally Tudor projects.[10] The most important loss is the now ruined four-storey mansion erected by the Seymour family inside Berry Pomeroy Castle (*c.* 1560–80), especially its almost completely vanished north range (*c.* 1600), whose use of columns and classical details showed an awareness of Sebastiano Serlio's treatise on architecture.[11]

4

John Shute, *Doric Order*, page from *The First And Chief Grovndes of Architectvre*, London, 1563, bound volume © RIBA Library Drawings and Archives Collections

Renaissance-inspired classicism of a less spectacular kind was a feature of the last quarter of the century. Its influence can be clearly seen in the redevelopment in the mid 1570s of Collacombe Manor, Lamerton, by Edmund Tremayne, who had spent two years in Italy.[12] Coincidentally, a Devon-born artist, John Shute (d. 1563), had travelled to Italy in 1550 as a servant of John Dudley, 1st Duke of Northumberland, to study architecture there. He returned to England with drawings of buildings, sculptures, and paintings which Northumberland showed to Edward VI. Shute's book, *The First and Chief Groundes of Architecture* (1563; cat. 4), was dedicated to Queen Elizabeth and was informed by

FIG. 3
Tomb of Frances Lady
Fitzwarren, Tawstock, Devon,
1589

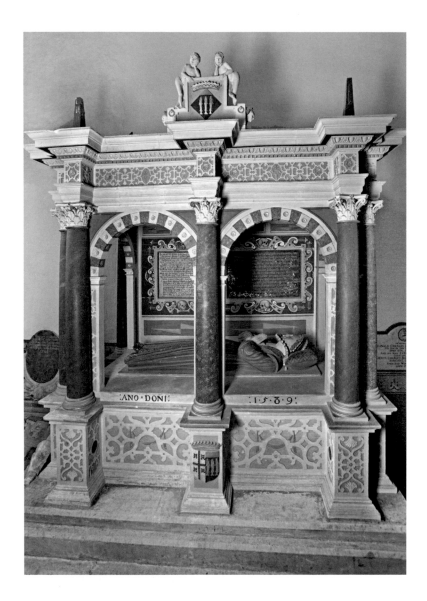

knowledge of Roman and Renaissance architecture. Notable for its treatment of the classical orders, it was the first architectural treatise published in England.

The classical columns on the tomb monument of Sir John Chichester (1569) in Pilton church, the monument to Sir Gawen and Sir Peter Carew in Exeter Cathedral and especially the monument of Frances Lady Fitzwarren (1589; fig. 3) in Tawstock church, with Corinthian columns in different coloured marbles, are memorable instances of this new classicizing taste, while the façade of Nicholas Ball's house in Totnes (1585) and the portico of Exeter Guildhall (*c.* 1592–95; fig. 4) are two prominent architectural examples in the region.[13] Commissions

FIG. 4
Portico of Exeter Guildhall,
c. 1592–95

like these reveal that some local patrons were responsive to new aesthetic ideals imported from the Continent. In like manner, decorative motifs in wood and plaster for the home, as well as designs for church monuments and carved pews, show that prints from across the Channel, principally from the Netherlands, provided a ready store of iconographic and decorative inspiration for craftsmen in Devon and Cornwall.[14]

The final area where material traces of the Tudor legacy can still be found concerns civic improvements. Four examples will have to suffice to indicate their variety. The decision to boost Exeter's trade by circumventing the medieval weir across the River Exe saw the city commission the Glamorgan engineer John Trew to construct the Exeter Canal (1564–66), the first pound-lock canal in the country, which enabled ships of up to ten tons burden to unload at the new Exeter Quay, completed in 1567.[15] In Tiverton John Waldron's almshouses (1579) are the best preserved of three such charities in the town established by merchants who had made their fortunes in the cloth trade.[16] In 1584 the Corporation of Plymouth presented a bill to Parliament to construct a watercourse (now known as Drakes Leat; cat. 5) from the river Meavy to Plymouth to provide clean water for the town, to supply fresh water for ships, to help fire-fighting and to flush silt from

Sutton Harbour.[17] Finally, in 1584–85 at Dartmouth the New Quay was constructed on land reclaimed from the river to facilitate the landing of catches from the Newfoundland cod fishery, one of the most important contributors to the region's economy.[18]

As this exhibition shows, the picture that emerges of Tudor Devon and Cornwall is rich and complex, with many physical reminders of its achievements still visible. With respect to historical developments, the variety of roles performed by the leading local names of the period as they contributed to regional, national and international concerns is equally striking. This was the golden age of the South West and it added a distinctive sheen to the effulgence surrounding Elizabeth I.

5
Robert Spry, *Chart of Plymouth Harbour and of the neighbouring countryside as far as Tavistock*, c. 1591, parchment © The British Library Board, Cotton MS Augustus II41

NOTES

1 William Camden, *Rerum Anglicarum et Hibernicarum Annales, regnante Elizabetha*, London, 1615; English translation by Richard Norton, *The historie of the most renowned and victorious Princesse Elizabeth*, London, 1630, p. 116.

2 Perkin Warbeck (*c.* 1474–1499) claimed to be Edward IV's younger son, Richard of Shrewsbury, one of the princes murdered by Richard III. He landed at Whitsand Bay, Cornwall, on 7 September 1497, hoping to capitalize on Cornish unrest, already seen in the Cornish Rebellion under Michael Joseph (Michael An Gof) and Thomas Flamank, which was defeated at Deptford in June that year. Acclaimed as Richard IV, Warbeck led a 6000-strong Cornish army and assaulted Exeter, before advancing on Taunton. Fearing attack he deserted his army and was captured at Beaulieu Abbey, Hampshire. Henry VII received the surrender of the remaining Cornish army at Taunton on 4 October 1497, and executed the ringleaders. Warbeck was hanged on 23 November 1499.

3 Russell was created Earl of Bedford on 19 January 1549/50 and his Exeter townhouse renamed Bedford House. It was demolished in the 1770s and on its site Bedford Circus was erected, destroyed by the Luftwaffe on 4 May 1942.

4 Three smaller blockhouses were also built, Devil's Point Artillery Tower (1537–39), guarding the Tamar; St Catherine's Castle (1538–40) at Fowey; and Little Dennis Blockhouse (1544–46), a sub-fort of Pendennis.

5 See Mark Brayshay, 'Defence Preparations in Devon Against the Arrival of the Spanish Armada: "So doth the state of this countrye reste quiet in orderlye readynes"', in Todd Gray (ed.), *Devon Documents: In Honour of Mrs Margery Rowe*, Exeter: Devon & Cornwall Notes & Queries Special Issue, 1996, pp. 20–26; Mark Brayshay, 'Plymouth's Coastal Defences in the Year of the Spanish Armada', *Transactions of the Devonshire Association*, vol. 119, 1987, pp. 169–96.

6 See Eamon Duffy, *The Voices of Morebath: Reformation and Rebellion in an English Village*, New Haven and London: Yale University Press, 2001.

7 See Frances Rose-Troup, *The Western Rebellion of 1549*, London: Smith, Elder & Co., 1913; also John Sturt, *Revolt in the West: The Western Rebellion of 1549*, Exeter: Devon Books, 1987; and Philip Caraman, *The Western Rising, 1549*, Tiverton: West Country Books, 1994.

8 The *Laws* comprises eight Books. The Preface and first four books (1593) and Book 5 (1597) were published in Hooker's lifetime, the remaining three were still in draft form on his death. See A.S. McGrade (ed.), *Richard Hooker and the Construction of Christian Community*, Tempe, AZ: Medieval & Renaissance Texts and Studies 165, 1997.

9 Richard Carew, *The Survey of Cornwall* [1602], London, 1769 edition, p. 64.

10 See Steven Pugsley, 'Landed Society and the Emergence of the Country House in Tudor and Early Stuart Devon', in Todd Gray (ed.), *Tudor and Stuart Devon: The Common Estate and Government*, Exeter: University of Exeter Press, 1992, pp. 96–118. Redeveloped buildings include Mount Edgcumbe House (1547–53), remodelled in the eighteenth century and restored after being gutted in the Second World War; Arwenack House, Falmouth, rebuilt by Sir John Killigrew (*c.* 1576–71) and rebuilt again in 1786; Penheale Manor, Egloskerry, rebuilt for George Grenville (*c.* 1572), remodelled in the 1630s and subsequently enlarged and redeveloped by Lutyens in the 1920s; Prideaux Place, Padstow (1592), remodelled in

the eighteenth century; the Rashleigh family seat at Menabilly, Fowey (1589–1624), rebuilt 1710–15 and extended in the early nineteenth century; Wembury House, east of Plymouth, built for Sir John Hele (*c.* 1592–1608), rebuilt in the late seventeenth century and demolished in 1803.

11 See Stewart Brown, 'Berry Pomeroy Castle', *Devon Archaeological Society Proceedings*, 54, 1998. The first five books of Serlio's *I sette libri dell'architettura* (Seven books of architecture) were published 1537–47 and were very influential in France, where he worked in the 1540s and 1550s, and the Netherlands. The first English translation was published by Robert Peake in 1611.

12 Sir Francis Godolphin's work on the family seat, Godolphin House near Helston (1570–1610), also included a classicizing courtyard gate using the Roman Doric order.

13 Ball, a Totnes merchant, owned a number of other properties in the town. His widow Ann married Thomas Bodley of Exeter, founder of the Bodleian library. For Exeter Guildhall see S.R. Blaylock, 'Exeter Guildhall', *Devon Archaeological Society Proceedings*, 48, 1990.

14 For examples, see Anthony Wells-Cole, *Art and Decoration in Elizabethan and Jacobean England: The Influence of Continental Prints, 1558–1625*, New Haven and London: Yale University Press, 1997.

15 See Kenneth R. Clew, *The Exeter Canal*, Chichester: Phillimore & Co., 1984. Trew's career is outlined in A.W. Skempton (ed.), *A Biographical Dictionary of Civil Engineers in Great Britain and Ireland Volume 1, 1500–1830*, London: Thomas Telford on behalf of the Institution of Civil Engineers, 2002.

16 The other almshouses are John Greenway's (1517) and George Slee's (1614), but both of these have been substantially altered since their erection.

17 The Bill was passed in 1585, but war with Spain delayed the construction of the leat until 1590–91. Water supplies for Plymouth had first been improved in 1570, when William Hawkins constructed at his own expense the New Conduit, associated with the Market Cross in Old Town.

18 See Percy Russell, 'The new quay at Dartmouth (1584–1640)', *Transactions of the Devonshire Association*, 82, 1950, pp. 281–90.

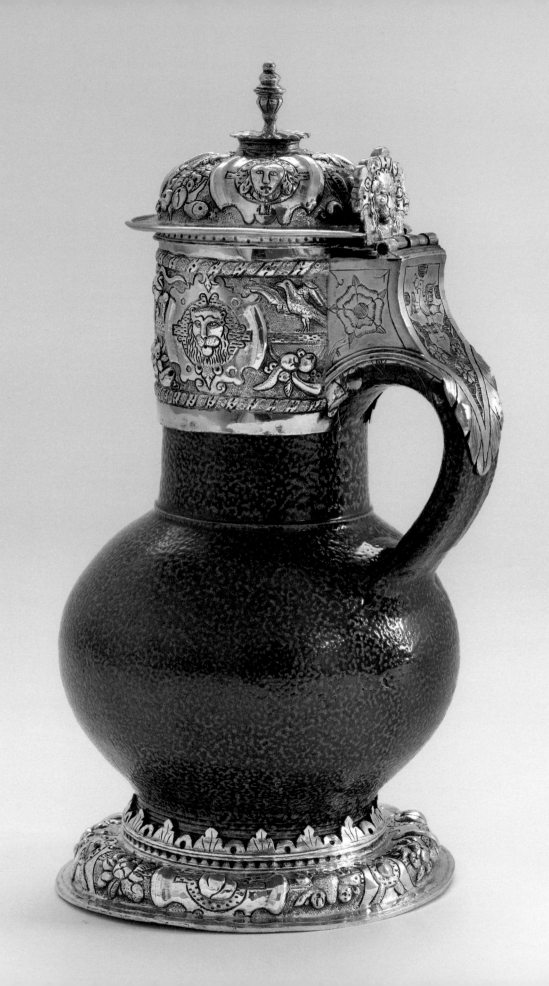

THE DECORATIVE ARTS
CHANGE & DEVELOPMENT
IN THE SIXTEENTH
CENTURY

Susan Flavin

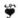

THE SIXTEENTH CENTURY WAS A VIBRANT and dynamic period in the evolution of the decorative arts in England. In general, however, interest in the artistic development of this period tends to focus predominantly on London and the Elizabethan Court, and as a result, our knowledge of the provincial arts remains patchy and under-researched.

A number of broad social and economic changes in this period had a major impact on demand for the decorative arts beyond the capital. Rising population and a massive inflation of food prices led to impoverishment and the deterioration of living standards for the labouring classes, but, in contrast, these changes increased the income of the middling groups in society, who benefited from rising property values and enjoyed increasing standards of domestic comfort.

In the West Country, these developments, along with the important cloth trade, a dynamic and adaptable local economy, and a number of successful mercantile enterprises, ensured that the middle and gentry classes had surplus money to invest in locally produced crafts, including jewellery, elaborate drinking vessels and household utensils, decorative plasterwork, richly carved moveable furniture, architectural stone and woodwork and fine needlework. Many of these items and features had practical functions in the lives of their owners. According to one chronicler, for example, plasterwork "maketh the room lightsome, is excellent against raging fire, and stoppeth the passage of dust".[1] Equally, however, they served to display the taste, wealth and status of their owners in an upwardly mobile society.[2]

A number of factors influenced the style of work in demand in this period. Increasing overseas trade, the settlement of communities of

6

Peter Quick, *Ornamental mounts on drinking jug, c.* 1580, salt-glazed stoneware with silver gilt mounts © Royal Albert Memorial Museum & Art Gallery, Exeter City Council

FIG. 5
The Grange, Broadhembury,
Devon, c. 1619. Reproduced by
permission of English Heritage

Breton and Dutch immigrants in the region, and the development of print culture all contributed to change, making craftsmen and their patrons more aware of Continental fashions and techniques and leading to the increasing integration of evolving Renaissance styles in locally produced work.[3]

Surviving examples of regional work dating to this period illuminate the Continental sources that influenced local fashions. It appears, in particular, that there was widespread fervour for Dutch Mannerist ornamentation in the West Country. Panelling from an unidentified house near Exeter, now at the Victoria and Albert Museum, shows that joiners used the 1565 ornamental designs of the Dutch painter and architect Vredeman de Vries, which supplied the pattern for two panels in the frieze.[4] Another panel is based on a print after Cornelis Floris, a Flemish architect and sculptor, while a fourth was adapted from a design by Abraham de Bruyn, a Flemish engraver. A further example of such influences is found in panelling from The Grange, Broadhembury (fig. 5).[5] The images carved on the main door were copied from a German manuscript published in 1563 and illustrated by

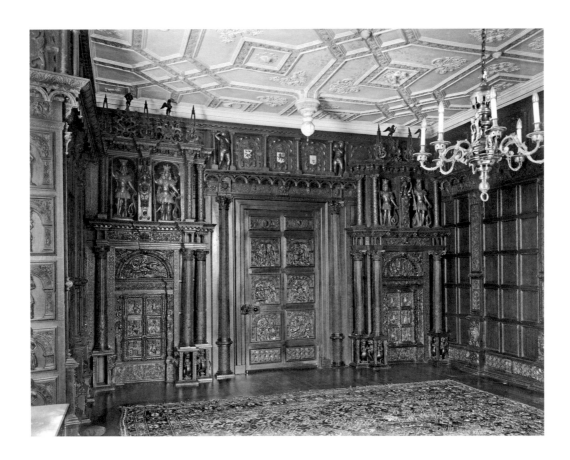

Virgil Solis, a German draughtsman and printmaker, while the other carved elements in the room were similarly inspired by European illustrations of classical subjects, again most notably the work of de Vries.

This use of Continental Mannerist motifs was widespread in English architectural decoration of this period and its occurrence in the West Country is to be expected.[6] As elsewhere in England, joiners, masons and plasterers worked closely together, observed each other's work and shared inspiration, and probably pattern books. A number of sixteenth- and early seventeenth-century houses, for example, have woodwork, plasterwork and stonework which appear to be closely related both chronologically and stylistically.[7] Indeed, these styles were thoroughly absorbed in West Country material culture. The collar added to a stoneware drinking jug produced by the goldsmith Thomas Mathew, for example, has an engraving on it that is similar to that found in the pattern books of Virgil Solis.[8]

While Continental decoration was diffuse in the region's crafts in the later sixteenth century, it is important to note that the fashion was not slavishly copied by craftsmen or their customers. The decoration noted on regional pieces is in fact unique to the West Country, and developed from the fusion of Continental and local vernacular styles. A wooden column from Paignton in Devon, for example, representing the story of Adam and Eve, shows familiarity with the works of de Vries and the sixteenth-century Italian architect Sebastiano Serlio. Nevertheless, while the column shows a number of features of classical ornament, the figures are carved in a vernacular style, showing how Continental ideas and fashions could evolve, depending on local tastes, conditions and skills.[9] Local artisans were aware of Continental influences and had access to designs and patterns, but chose to interpret these independently to satisfy the local market.[10]

The growing influence of Continental styles was not restricted to domestic architecture and furniture in this period. From the second half of the century, church monuments also began to show Renaissance features, such as classical columns, wreaths, strapwork and round arches. The Harvey tomb at Exeter Cathedral (1564; fig. 6), which was probably built in Exeter, possibly in a workshop that was located in or near the Cathedral mason's yard, shows the early development of Renaissance style in the region's monuments.[11] The tomb is a traditional form of niche tomb but the carver has introduced new forms into the structure and the decoration is a mixture of traditional and newer Franco-Italianate ornamentation.[12] Gradually this style

evolved, and Italianate and French details were replaced by Mannerist styles. This can be seen, for example, on the Pole monuments at Colyton (1587 and 1588) and three other, seemingly related East Devon monuments, which all show familiarity with Mannerist architecture, including Mannerist strapwork and the architectural Orders.[13]

Changes in the style of monuments and, more broadly, in the ways in which society's elite wanted to be memorialized in the sixteenth century were not just the result of Renaissance influences. The Protestant Reformation also had a significant impact on the material culture of devotion and commemoration in the region. Prior to the Reformation, commemoration was tightly linked to the need of the deceased to obtain the prayers of the living for the sake of their soul. The early sixteenth-century cadaver tomb of Preceptor Sylke at Exeter Cathedral typically shows this preoccupation, being inscribed with the words: *I am what you will be, and I was what you are. Pray for me I beseech you*. The dissolution of monasteries and chantries removed this emphasis and redefined popular attitudes to funerary monuments, stressing instead the life and honour of the person commemorated.[14]

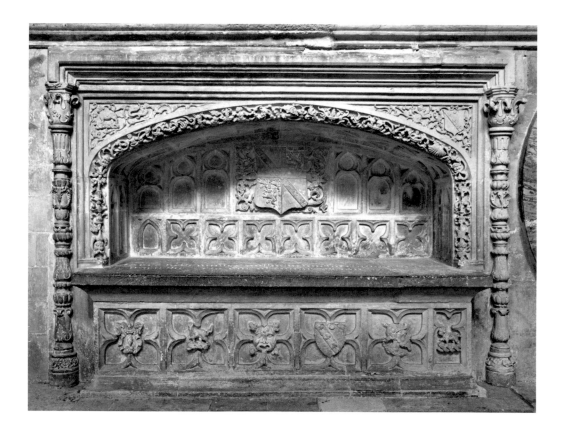

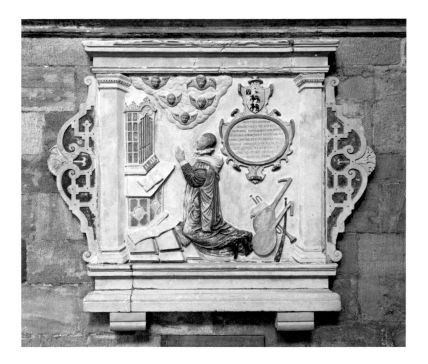

FIG. 7
The Godwin Tablet, Exeter
Cathedral, 1586. By kind
permission of Exeter Cathedral

This widened the possibilities for more innovative monumental imagery and epitaphs. The memorial tablet to Matthew Godwin (fig. 7) also at Exeter Cathedral, for example, which has been described as a piece of pioneer sixteenth-century carving, depicts the deceased, a musician at the Cathedral, kneeling as in life and surrounded by his instruments, which serve to celebrate his individual achievement and contribution to religious life.[15]

Changing religious ideology had important implications beyond stylistic developments for the work of the region's craftsmen. The surviving churchwardens' accounts of local parishes vividly show the impact of the Reformation on the working practices and wealth of the region's craftsmen in the later century. In every parish the records show the employment of local craftsmen to destroy the art and architectural features of Catholic worship and replace them with Protestant furnishings, often at considerable expense. In the parish of St Petrock, between 1560 and 1561, for example, a carpenter was paid 4s. 10d. to remove the rood, rood loft and "pageants", and 5s. 6d. to take down the altar, while in 1562, the parish paid the huge sum of £11 18s. 3d. for a new seat for the priest and a new pulpit.[16]

The pockets of goldsmiths possibly fared best from the changes sweeping the country in the Reformation. In the 1570s, all over the

region, Archbishop Parker directed a campaign of calling in and melt-
ing down pre-Reformation chalices, which were seen as the "last
remaining relic of popery".[17] These were then refashioned as simple
Protestant communion cups. This was an expensive exercise for local
parishes. In 1575, for example, the parish of Kilmington sold their
chalice to John Jones for 30s.[18] The Crown, keen to capitalize on reli-
gious reform, took a cut of 20s. from the sale, "to the queens mageste
use".[19] The parish then paid Jones 49s. 6d. for a communion cup and
a further 6d. for bringing the cup home from Exeter. In other words,
they paid five times what they received for their chalice to acquire a
standardized communion cup.

Tax assessments suggest a boom in the wealth of some goldsmiths in
the years of chalice remaking.[20] Thomas Mathew, a prolific Barnstaple
goldsmith, for example, was assessed at £5 in 1571, £10 in 1582, and £3
in 1592.[21] Likewise, John Jones, who 'changed' more than a hundred
chalices into cups in this period, was assessed at £14 in goods in 1577
and at £16 in 1582. Jones was certainly one of the wealthiest and most
prolific goldsmiths in the region (cat. 7). His wealth was such that he
presented the mayor of Exeter with a parcel-gilt ewer and basin in
1576 and, when he died, disposed of extensive property in and around
Exeter in his will.[22] Jones, however, was clearly at the top end of the
scale and, as with every craft, the level of success of goldsmiths was
variable. In comparison, for example, John Friend of Salisbury was
described in 1633, as a "poore workeinge goldsmith", who had pawned
five bodkins.[23]

One further key factor influencing the nature of regional styles and
the quality of local work in this period was access to raw materials. The
very high cost of freighting heavy stone and wood meant that work
was generally undertaken using materials that were close at hand, and
that patrons, probably for economic reasons, preferred to commis-
sion monuments from the carvers whose workshops were located
relatively locally.[24] This led to the development of distinct decorative
styles in different parts of the West Country. With regard to monu-
ments, for example, in East Devon a group of five similar monuments
have been identified, all carved in Beer stone. These, which include
the aforementioned Pole monuments at Colyton, the tomb of Anne
Bartlett at Branscombe and the Drake monument at Musbury, are
all within a tenmile radius of Beer on the coast, suggesting that they
were produced by a mason or workshop sited at the quarries there,
supplying monuments to patrons in the immediate vicinity. These are

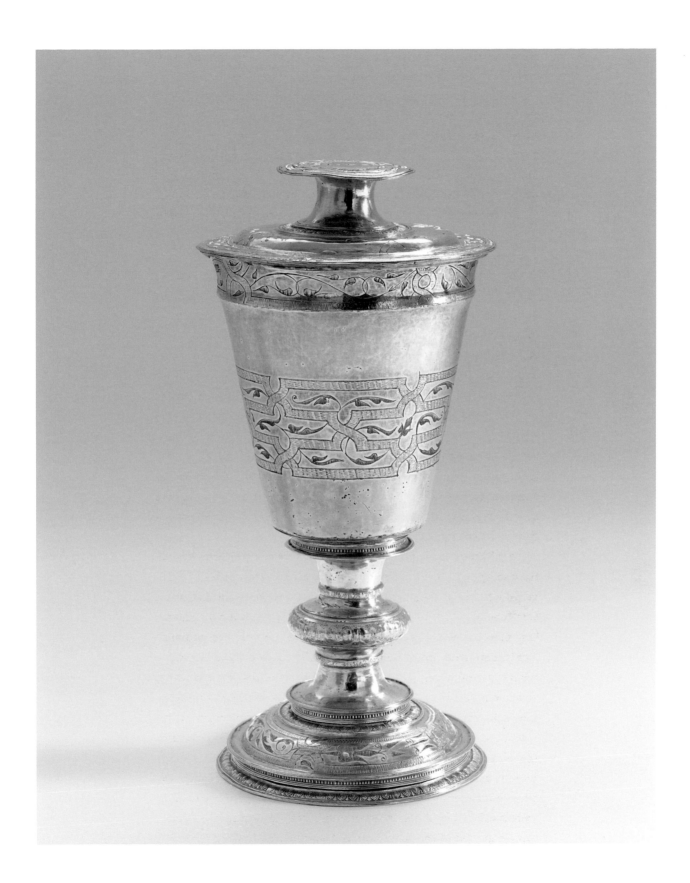

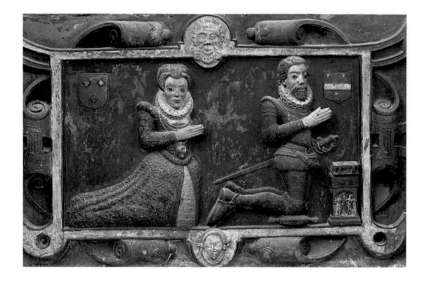

all within a ten mile radius of Beer on the coast, suggesting that they were produced by a mason or workshop sited at the quarries there, supplying monuments to patrons in the immediate vicinity.[25] On the far western fringes of Devon, and in Cornwall, a very different style of monument evolved, carved from Cornish and Devon slate, rather than free stone. A slate memorial to John Wrey in Tawstock was carved, possibly by Peter Crocker, a Cornish mason, as was the Budockshead monument at St Budeaux (fig. 8).[26] These monuments are unlike any others in the region. The inherent characteristics of slate meant that carvers were more restricted in their use of decoration and as a result figures on slate memorials tend to be more naïvely interpreted than more eastern, freestone examples.[27]

Craftsmen in this period, whether itinerant or attached to static workshops, commonly supplied their own raw materials as part of the terms of their commissions. Raw materials were sourced by exploiting local resources and also by recycling worn or old-fashioned items. West Country Elizabethan furniture was frequently produced using recycled woodwork. At Morebath, in 1564, for example, the parish paid just 6d. for a seat for the priest, suggesting almost certainly that they were reusing older wood, possibly from the dismantled rood loft.[28] This appears also to have been the case at Ashburton, where a desk was made for the vicar in 1566, again at a cost of only 6d.[29] This practice was not restricted to church furniture, however, and modern experts report the common use of recycled materials in certain types of sixteenth- and seventeenth-century furniture, in particular, for some unknown reason, gateleg tables and sideboards.[30] This

recycling, particularly on apparently high-level pieces, has been taken as an indication of a serious dearth of wood in the region, one which allegedly had a major impact on the relative quality of sixteenth-century West Country furniture.[31]

There is certainly plenty of evidence of local concern for wood resources in the later century. In his survey of 1599, John Hooker, the city Chamberlain under whose jurisdiction the city wood resources fell, referred to the tradition that the shire had once been much more heavily wooded while now there were few lands not enclosed either for tillage or for sheep.[32] There is also evidence that craftsmen were prepared to invest very large sums of money to ensure their own supply of wood. In 1609, for example, carpenter Richarde Woodwarde of Tiverton was paid £216 "for trees and woods of oak and ash growing in Narracott Woode".[33] People also had an acute awareness of the need to sustain local resources. A lease of land to the Cholwiches in Palstone in 1603, for example, stipulated that for every tree they used for timber they must plant three new oak, ash or elm trees and that they would also plant 60 trees within ten years.[34]

The apparent pressure on wood supplies is, however, not surprising and was not unique to the West Country. Wood was the main fuel for homes and a vital commodity in many industries, such as ship building, iron smelting, silver and tin mining and glass and soap-making. It was therefore in constant demand. Wood was also the basic construction material for houses, and the sixteenth century has been noted as a period of extensive re-modelling and re-building in England.[35] These pressures on resources meant that large areas of the country suffered from an acute scarcity of wood at varying times in the sixteenth century.[36] The practice of recycling was not unique to Devon and the quality of woodwork produced in the region was probably not inferior to that produced elsewhere in the period.[37]

Periodic wood shortages alone are probably not enough to explain the widespread practice of recycling. Relatively speaking, furniture production did not require huge amounts of oak, and no doubt it was partly the sheer effort required in harvesting a piece of oak – with the tree having to be felled, then pit-sawn into planks, stacked, dried and seasoned – that explains the tendency throughout the country to re-use oak wherever possible.

Goldsmiths

While it is possible to examine broad trends in the development of the region's decorative arts in this period, it is difficult to develop a detailed picture of the lives of craftsmen, how their trades were organized and regulated, how they interacted with each other and their patrons, or how they trained their apprentices. Indeed, in most cases, even identifying important regional workshops is a challenging task.

Of the arts, the work of the region's goldsmiths is by far the most open to inspection. This is because, in contrast to other craftsmen, goldsmiths generally initialled their work with their maker's mark. In addition, although no records survive for any relevant sixteenth-century guilds in the region, provincial goldsmiths remained under the control of the London Goldsmith's Company, whose charters, from *c.* 1500, gave them right of jurisdiction over all workers of gold and

SIXTEENTH-CENTURY GOLDSMITHS[38]	
Exeter	*Barnstaple*
William Cotton I (d. *c.* 1533)	John Davy (d. 1581)
William Smith (d. 1556)	Simon Hill (d. 1596)
William Cotton II (d. after 1575)	John Cotton (d. 1601)
James Walker (d. 1562)	Peter Quick I (d. 1610)
Henry Hardwycke (d. 1571)	Thomas Mathew (d. 1611)
John North (d. 1574)	Richard Diamond (d. unknown)
John Jones (d. 1583)	
Richard Hilliard (d. 1594)	
George Lyddon (d. 1598)	
Richard Osborne (d. 1607)	
Christopher Easton (d. after 1609)	
Steven More (d. 1613)	
William Horwood (d. 1613)	
John Eades (d. 1616)	
William Bently (d. 1618)	
John Averie (d. 1622)	
William Bartlett (d. 1646)	
Jeremy Hilliard (d. 1631)	
Richard Bullyn (d. unknown)	
William Nicholls (d. unknown)	
William Pynnefolde (d. unknown)	
Philip Dryver (d. unknown)	
John Deymond (d. unknown)	

silver in England.[39] The surviving records of the London Company can therefore help to show how the trade was organized and how its standards were maintained in this period.

In practice, control from London meant that goldsmiths who were not freemen of the London Company were required to take an oath that they would use only true gold and silver, and do no work in latten or copper, "whereby the king and his people might be deceived".[40] This was important because of the association of the standards of coinage with the making and selling of gold and silver objects. Goldsmiths were forbidden to produce silver wares of poorer quality than coinage.[41] They also swore that all their work would bear the mark assigned to them by the Company; that they would not set counterfeit stones in gold; and that they would inform the wardens if they knew of any "deceptive work … put to sale".[42] Compliance was policed and enforced by the implementation of Searches. Wardens would ride out to provincial towns with a clerk and the necessary equipment to inspect and assay.[43] The penalties for non-compliance varied, ranging from being required to take the oath, having sub-standard objects cut into pieces with shears, being fined, or prosecuted at Court.[44]

The London Company Minute Books show that a number of Searches took place in the sixteenth century. In 1561, for example, Warden Gilbert conducted a Search which took him through Exeter, where William Cotton, John Jones, Richard Osborne, William Nicholls and Steven More, all prominent craftsmen, were found in possession of substandard work.[45] Steven More was fined for producing defective spoons and hooks, which were broken by the Warden. He did not learn his lesson, however, and in 1571, during another major Search of the West Country, More was fined again for "coarse ware". More was not the only goldsmith in trouble that year. In Exeter and Barnstaple a number of goldsmiths were fined, and others, including Richard Hilliard (cat. 8) and Jones, were "bound to the wardens in £10 for true workmanship".[46]

Beyond the regulation of standards, there were other links between London and West Country goldsmiths in this period and it was not uncommon for the son of a provincial goldsmith to be placed as an apprentice with a member of the London Company.[47] This served both to show the prosperity and status of the goldsmith and to allow his son to gain different skills and meet a range of important and influential people – the equivalent to training at a prestigious firm today. Boys were taken by goldsmiths as apprentices for a term of seven to ten

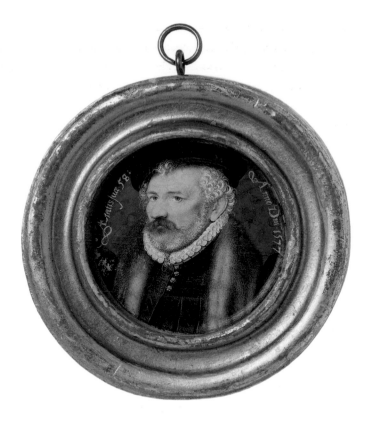

years. These boys were expected to be well educated, since in the 1490s
it was ordained by the Company that apprentices must be able to read
a passage out loud to the Wardens and write in English and Latin. The
first surviving London Apprentice Register was started in 1578 and each
entry was written and signed by the boy himself.[48]

Training was also undertaken in Devon, however, and the Freemen's
Rolls provide information on the names of locally trained apprentices,
some of whom went on to become fine goldsmiths in their own right.
John Jones, for example, trained at least five apprentices, including
Christopher Easton, John Eades and William Bently.[49] Little is known
about how such training was organized, but local guilds certainly had
some control in this regard. In 1631, for example, two individuals in
Barnstaple were indicted for using "the art and mystery of a goldsmith
having never been apprenticed to the trade".[50] It also seems that differ-
ences existed in the regulation of training in London and the West
Country. In the better trades, which included goldsmiths, apprentice-
ship usually started at the age of fourteen. Indeed, by the "custom of
London" those apprenticed in the City had to be over fourteen and
under twenty-one.[51] Evidence from the West Country, however, shows

that apprentice goldsmiths might be as young as twelve. In 1593, for example, John Jones, aged twelve, was bound to Thomas Bond, a goldsmith in Bridgwater.[52] Little is known about the conditions or treatment of young apprentices in the region. Given the high status of the trade, goldsmiths probably fared well. Certainly there is evidence than some masters took their duties very seriously. John Walker, an Exeter goldsmith who left money in his will as an interest-free loan to help "young men" in their livelihoods, was very careful to ensure the well-being of his apprentices after his death, stating that they should be allowed to finish their training and have any money or benefits owed to them.[53]

Owing to the high status of the craft, successful goldsmiths were often well connected and held important civic positions within their towns. Richard Hilliard and John Jones, two of Exeter's most prolific goldsmiths, served as Bailiffs. Hilliard also served variously as a Common Councillor and Sheriff, while Jones served as a Churchwarden at St Petrock's. Likewise, Barnstaple's Thomas Mathew was a Capital Burgess. These men were civic-minded, influential and often altruistic members of their communities and most of them left substantial bequests to the poor in their wills.[54] Indeed, by virtue of their prominent civic roles, we sometimes gain insight into the personalities of these men. Hilliard for example, who played a key role in a bitter civic feud that developed in Exeter following the founding of the Merchant Adventurers Company, was described by Sir John Mason as a "busy and prating fellow and a vauntparler [a boast]" and was 'fired' from his position as a deputy for being obstructive.[55]

The greatest market for West Country silverware in this period came from local citizens. Wills and inventories show the large range of plate and jewellery in use as well as the types of individual who purchased it. The most commonly found silverware in the Exeter inventories are spoons, bowls, cups and salts.[56] As well as their practical usage, these items had a number of social and economic functions. Wills show that silverware was often a treasured family possession, handed down through generations. It was also an important investment that could be melted down or exchanged for ready cash when needed.[57] John Gord of Crediton, for example, left spoons to each of his sons but included a proviso that if his wife had to sell them the children could not have them.[58] Silverware also had commemorative and political functions, and items might be given as gifts to show political allegiance or affiliation. Spoons in particular were a customary gift from sponsors to their godchildren at christenings.

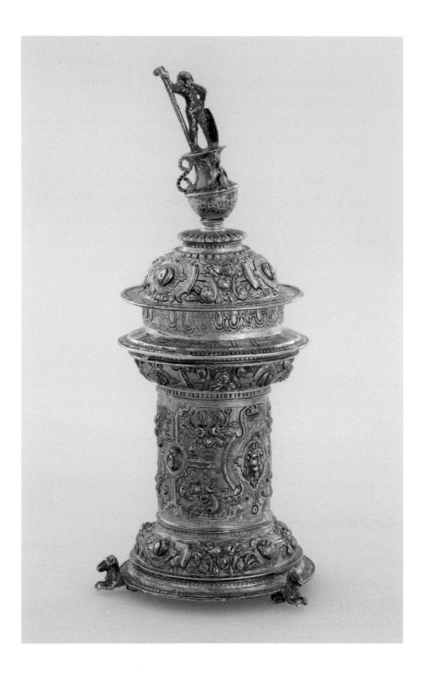

At the elite level of society, the Exeter inventories show that indi-
viduals might pay up to a staggering £9 for a single item of domestic
plate. Merchant Thomas Prestwood, for example, whose inventory is
transcribed below, had a cup valued at £8 10s. 6d., and a salt at £9 2s.
8d. Such grand items of domestic plate, like the famous 'Exeter Salt'
by Christopher Easton (fig. 9), were of great importance in the ritu-
als of dining in elite households in the sixteenth century. It has been
suggested that the standing salt served a primarily decorative function

rather than to hold salt for the meal. It held a prominent position on the table, to the right of the host, indicating his status and prosperity.[59] This was also the case with great standing cups, which were commissioned as sideboard display plate and were not intended for everyday use, but rather to impress visitors. These cups were also associated with a number of complex social customs and rituals.[56]

A note of plate in the inventory of Thomas Prestwood [61]

Item a nest of goblets double gilt with his cover weighing 86 ounces and a quarter at 5s. 2d. the ounce — £22 5s. 7d. ½;

Item a standing cup double gilt weighing 33 ounces at 5s. 2d. the ounce — £8 10s. 6d;

Item a salt with a cover double gilt weighing 33 ounces at 5s. 2d. the ounce — £8 10s. 6d;

Item two little white bowls weighing 14 and a half ounces at 4s. 8d. the ounce — £3 7s. 8d;

Item a salt parcel gilt weighing 13 ounces and 3 quarters at 4s. 10d. the ounce — £3 6s. 4d;

Item a little salt double gilt weighing 2 and a half ounces at 5s. 4d. the ounce 13s. 4d;

Item a goblet parcel gilt weighing 16 ounces at 4s. 8d. the ounce £3 14s. 8d;

Item an ale cup double gilt weighing 15 ounces quarter and half quarter at 5s. 4d. the ounce — £4 2s;

Item an ale cup double gilt weighing 12 ounces and half — £3 6s. 8d;

Item an ale cup with his cover double gilt weighing 11 and a half ounces at 5s. 4d. — £3 1s. 4d;

Item an ale cup with his cover double gilt weighing 9 ounces at 5s. 4d. the ounce — 48s;

Item a casting glass weighing 5 ounces at 5s. the ounce — 25s;

Item a toonn [?] with his cover p[arcel] gilt weighing 45 ounces quarter at 5s 2d the ounce £11 13s;

Item a fork weighing 1 ounce half quarter 6s;

Item two dozen spoons weighing 32 ounces at 4s. 6d. — £7 4s;

Item two great jugs weighing 15 ounces at 5s. the ounce — £3 15s;

Item three little cups of stone covered weighing 9 ounces — 36s. 8d;

Item a branch of silver 2s. 6d;

Sum £98 11s. 5d.

Beyond the social elites there was a further healthy market for the wares of West Country goldsmiths. Before the introduction of the fork, spoons played a central role at meals and it has been noted that persons of every rank strove to possess a silver spoon and that it would be difficult at "any time for the last six hundred years to find a man, of however humble station, without a spoon to bequeath to his widow or his son".[62] Other items, too, were popular with the less well off. Estienne Perlin, writing in 1558, noted that the English "consume great quantities of beer double and single and do not drink it out of glasses, but from earthen pots with silver handles and covers, and this even in houses of persons of middling fortune".[63] These stone pots were imported from the Rhineland in vast quantities in the late sixteenth century.[64] The pots themselves were relatively inexpensive, costing just a few pence, but the mounts could cost up to an additional two or three pounds.[65] Local earthenware was also commonly used.

There was certainly a big demand for these in the West Country. Stone cups and jugs with silver covers, handles or feet are a very common find in the Exeter inventories. Rowland Fabyan, a cordwainer from Exeter, for example, owned two silver covers for two stone cups weighing three ounces, valued at 12s. The mounts for such stone vessels were certainly obtained locally. A number of late sixteenth-century pieces of Frechen stoneware with mounts produced by Peter Quick of Barnstaple still survive (see cat. 6).

While wealthy clients would probably have had goldsmiths call on them to discuss commissions, the less affluent would have visited the goldsmith at his shop. Some excellent evidence exists to show the nature, location and contents of goldsmiths' shops and workshops in Exeter. Leases show, for example, that Exeter goldsmiths, like their London counterparts, worked in very close proximity to each other.[66] In Exeter, the prime sites were close together around the Guildhall and Broadgate, in the parishes of St Martin and St Petrock.[67] Their shops appear to have been small in size. A counterpart lease to William Cotton Goldsmith in 1556, of a shop on High Street in St Pancras parish, gives the dimensions of the shop as being 21 feet long, 6 feet wide, and 9 feet high. This seems tiny, especially as many contemporary illustrations show that the goldsmith's shop often also functioned as his workshop and store room. Nevertheless, a typical shop in London would probably have been of a similar size in this period.[68]

It is likely that goldsmiths' shops had a window opening on to the street and that the products of their trade were exhibited in the

shop front.[69] A surviving inventory of an Exeter goldsmith, William Horwood, provides valuable information on what stock such shops might have held. His inventory includes silver bowls, salts, spoons, lace, garnished coral, gilt rings, stones and pearls for rings, gold rings and jewels, broken silver, gilt beakers and Spanish and English money. The total value of his stock came to the very significant sum of £104, indicating that his business was very healthy. The inventory also lists a pair of balances and weights and "all the tools in the shop".[70] These are not named, but their presence suggests that the shop did indeed also function as the goldsmith's workshop. Other inventories from the late sixteenth century also include goldsmith's tools. William Seldon, a merchant of St Petrock, may have been providing local goldsmiths with their tools, since his inventory of 1575 contains 24 gold files, four goldsmith's brushes of hair and and three goldsmith's hammers.[71] Likewise the inventory of Richard Mogridge contains two pairs of goldsmith's bellows.[72] These tools are typical of what we would expect to find

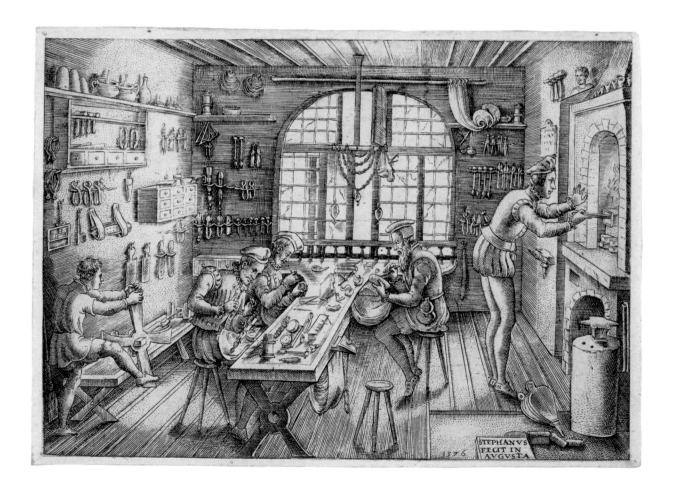

41

in the workshop of a sixteenth-century goldsmith and compare well to contemporary illustrations and engravings (fig. 10).

During the sixteenth century, goldsmiths made use of silver mined at Bere Ferrers and Bere Alston in South Devon, and also in the Mendips.[73] In North Devon, the mine at Combe Martin was described as "almost worn out" in 1490. In 1587, however, a rich new supply of silver was discovered by Adrian Gilbert (brother of Sir Humphrey).[74] This was mined successfully by Gilbert with the help of the mining expert Bevis Bulmer. It is possible that the famous Gilbert spoon (cat. 9), which bears for its finial the Gilbert family crest of a squirrel, and was made by John Eades in 1580, was made using metal from Gilbert's mine.[75]

Wood, stone and plasterwork

The sixteenth century was a period of so-called 'Great Rebuilding' in England, when improved economic conditions led to the expansion, rebuilding or architectural improvement of large numbers of buildings throughout the country. The integration of decorative architectural features in such projects, in particular elaborate ceilings, overmantels and panelling, was a means of displaying taste, wealth and status. Decorative plasterwork, in particular, was one of the most fashionable additions to the Elizabethan country house. The trend began at Court in London, where Henry VIII (Nonsuch Palace, Surrey) and Cardinal Wolsey (Hampton Court) were early patrons of the style, but it was soon emulated by the rest of the royal Court, followed by the provincial gentry and merchant classes.

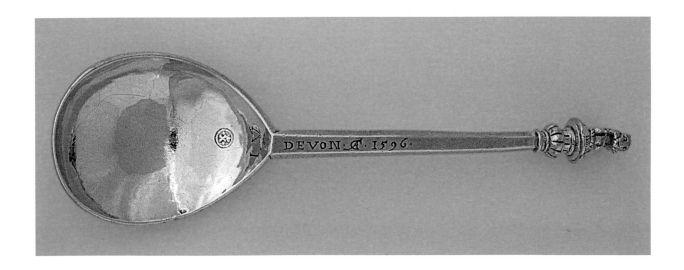

FIG. 11
Detail of plasterwork from the Long Gallery ceiling at Holcombe Court, Holcombe Rogus, Devon © Catherine Wander

Much high-quality regional decorative architectural work still exists for this period. Devon is particularly renowned for its survival of early plasterwork ceilings, which, owing to the relative wealth of the region, found a market not only among courtiers and the mercantile elite but also among the lower gentry and, by the seventeenth century, even the yeoman farmers.[76] Indeed, plasterwork seems to have been quick to find a market in the region. The earliest surviving example of decorative plasterwork in Devon, the Long Gallery ceiling at Holcombe Court, which was probably installed before 1566, is amongst the earliest surviving plasterwork in Britain (fig. 11).

Early ceilings, such as those found at Holcombe Court and the post offices at Colyton and Bowringsleigh, Kingsbridge, usually took the form of interlaced patterns of single ribs, with the panels between the ribs sometimes decorated with floral sprays, heraldic designs, fleur de lys and the Tudor rose. Over the course of the century, however, fashions evolved and designs became increasingly complex and refined. By the end of the Elizabethan period, increasing numbers of Renaissance motifs were employed, often alongside Tudor motifs. Designs began to incorporate flowers, fruit, exotic birds and beasts, fishes and insects, and the simple rib design gave way to elaborate enriched varieties, consisting, for example, of a running vine pattern.[77] The sources for these designs were eclectic. They included engraved plates in printed books like those by Abraham de Bruyn (1581), along with imported luxury

goods such as silverware, tapestries and carpets which bore fashionable decorative designs and motifs.[78]

In the past, much of this regional plasterwork has been attributed to Flemish, Italian and Dutch craftsmen. Recent research on the techniques and styles employed in Devon's plasterwork, however, suggests that the majority was undertaken by highly skilled local craftsmen.[79] The construction of the plasterwork, for example, developed not from the Continental stucco technique using plaster of Paris, but from the native vernacular tradition of lime plaster.[80] Likewise, while Continental Renaissance styles were incorporated later, the earliest work was more closely related to English Tudor Gothic than to Renaissance ornament.[81]

While we can be fairly sure of the local origin of this work, the identities of the region's plasterers are obscure. Decorative work for this period was very rarely signed or dated, and, as with metalwork, the survival of commissions is rare. This dearth of information has led to the development of much conjecture surrounding the identification of regional workshops. With regards to plasterwork, in particular, the Abbott 'family' of plasterers tends to be linked to almost every surviving piece of architectural plasterwork in the region, despite the fact there is no evidence that any sixteenth-century Devonshire Abbotts were plasterers.[82] The only Abbott confirmed as a decorative plasterer is the seventeenth-century John Abbott, who created the magnificent ceiling of the Custom House in Exeter in 1681.

While the craftsmen responsible for Devon's plasterwork may remain anonymous, some tentative suggestions have been made recently about the number of workshops operating and the amount of training undertaken in the region. Plasterwork patterns were created by highly skilled craftsmen, who worked the plaster *in situ* with moulds or special tools. It is likely that each workshop possessed their own moulds and pattern books, which explains why similar motifs and patterns recur in different houses in the same areas. An identical pomegranate design, for example, appears at Alphington Rectory, Bradninch Manor, Bradfield House, The Grange, Broadhembury, and at Forde House, Newton Abbot.[83] On the basis of differing repeating styles, it has been suggested that four main 'firms' existed in the region, alongside several, smaller more local enterprises.[84]

Other evidence, too, supports the existence of a number of important local workshops. The records of the London Company of Plasterers, for example, show that, between 1597 and 1662, 1350 apprentices trained in London, and that every county in England sent some

of its young boys to the capital to learn the trade.[85] What is interesting is the relative numbers of apprentices that arrived in London from different parts of the country. London and the Home Counties sent 475 boys, 433 came from the Midlands, while Somerset, Wiltshire and Gloucestershire together dispatched 120 apprentices to the capital. Out of a total 154 apprentices that were sent from the far southern and western counties, only ten were from Cornwall, Devon and Dorset.[86] This strongly suggests that the region was a major centre for decorative plasterwork production and training during the period.

While no workshop or school can be firmly linked to the region's plasterwork, a number of potentially important joiners and masons workshops have been identified by historians. The lists of Exeter freemen show that a family named Garrett, also known as Hermon, produced a total of seven joiners and took three apprentices between 1586 and 1619.[87] Martin Garrett was financially successful, but the only work firmly attributed to this family, to date, is the panelling around the altar at St Petrock's in 1572–73, which no longer survives, but was completed for the large sum of £4 10s.[88]

Also of importance was Nicholas Baggett. Baggett was commissioned to carve an elaborate new door during the Elizabethan rebuilding of Exeter's Guildhall, c. 1593.[89] He, along with two other carpenters working on the project – John Clavell and John Shapster – were apparently held in high esteem as craftsmen, since city records show that the Chamber set out to find "expert workmen" for the project.[90] Baggett's door, which cost the city £4 10s., is one of a group of similar Exeter doors, including one from the High School in the High Street now in the Royal Albert Memorial Museum & Art Gallery, datable to c. 1590–1620 (cat. 10).

A number of masons were employed on the important Guildhall project. Arnold Hamlyn, who held a tenement in Guinea Street and may have had a workshop there, was entrusted with the most intricate decorative and figure carving on the project.[91] Unfortunately, aside from the capitals he carved at the Guildhall, only one example of his figure-work survives, an effigy of Queen Elizabeth that was originally placed on Little Conduit in the High Street. Given that the piece was commissioned by Exeter's civic authorities for display in such a public meeting-place, Hamlyn's carving was probably very highly regarded.[92]

Also employed on the project was the mason Richard Deymond and his apprentice John Deymond. Richard has tentatively been associated by historians with an important group of 'tester' monuments (effigies

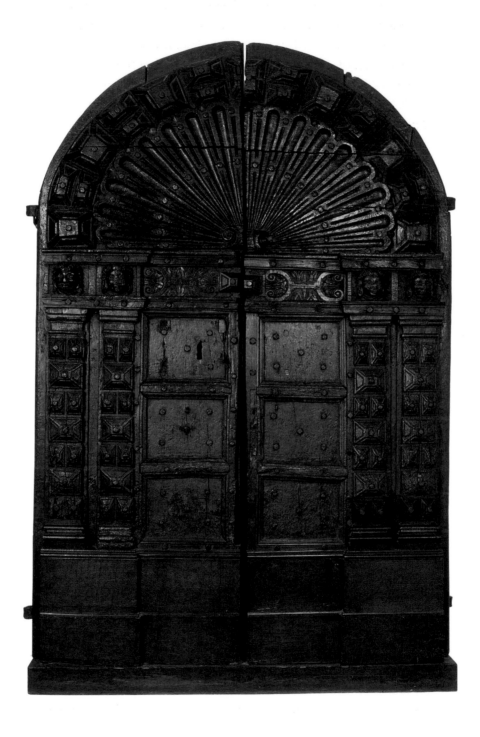

of the deceased placed under an overhead canopy, resting on columns) and mural tablets dating from *c.* 1586 to *c.* 1607, which were built from local stone and are located in close proximity to Exeter, suggesting that the city was a major centre of production in this period.[93] His apprentice John has recently been identified as the carver responsible for a series of very important early seventeenth-century monuments, including those of Sir Thomas Fulford at Dunsford (1610); Sir John Jeffrey at Whitchurch Canonicorum (d. 1611); Sir John Acland at Broadclyst (1613–14) and Sir Nicholas Eveleigh at Bovey Tracey (d. 1618; monument 1620). Nothing much is known about either John or Richard, but evidence from the Exeter Orphans Court Inventories shows that Richard lived in the suburbs outside the South Gate of the city.[94]

The operation of the secular market for wood, stone and plaster-work remains obscure for this period and we know very little about the working conditions and terms of employment of craftsmen. On the other hand, the rich survival of sixteenth-century parish accounts sheds significant light on the working lives of craftsmen employed by the Church. At the lower end of the scale, the accounts record regular payments to named carpenters and joiners relating to maintenance work such as mending roofs, erecting scaffolding, making bell and window frames, and mending or making pews. For this sort of work, carpenters were paid a daily rate of between 10d. and 14d.[95] In many cases they were also supplied with food and drink, as part of the agreement.[96] At Patton, in Somerset, a carpenter called Crosse, who was employed to make a rood screen and a font, was supplied with ale by the parish "in certain times in his work to make him well willed".[97]

With regard to more prestigious work, records of the parish of Morebath provide good evidence of the conditions under which a craftsman might be employed. In 1535, for example, the parish commissioned William Pophyll to carve an elaborate high cross with images of Mary and John on either side. The crucifix cost the village a staggering £7, which was more than two thirds of an entire year's income.[98] Pophyll was given no specific design for the project but was simply required to keep the village 'ahead of the Joneses' by making the cross either the same or better than the one at neighbouring Brushford.[99] As was often the case with such commissions, Pophyll had to find all the necessary raw materials himself.[100] He was then paid in successive instalments, over a period of almost two years, until his work was completed.[101]

As the skills and employment opportunities of craftsmen working in these trades varied significantly, so too did their relative wealth

and status. The Orphans Court Inventories contain detailed accounts of the goods owned by two Exeter joiners in 1596, Philip Josyln and Richard Hedgland. Joslyn, it seems, was a wealthy man. The total value of his goods amounted to a substantial £24 15s. 10d. He owned fine hats and clothing, flower pots, pewter tableware and a carpet. Attached to his home was a substantial workshop, containing four workbenches. His inventory is of great interest, providing a snapshot of the contents and commissions of a successful city workshop. It contained unfinished items including a table, "press" (or cupboard) and panelling, along with all the tools of his trade – hammers, planes, compasses, wimbles and chisels.[102]

In contrast to Joslyn, Hedgland's goods were valued at only £3 19s. 5d. Although he was far from poor, he lived a modest life, owning tin rather than silver spoons and possessing no luxury items.[103] It is likely that his work was lodged at the lower end of the market and that he produced utilitarian furniture that was in daily use in the more humble dwelling rather than high-quality elite items.

Status also varied considerably for these craftsmen. While perhaps not among the civic elite, like goldsmiths, the region's most highly skilled joiners, masons and plasterers were respected, well connected and active members of their communities. Nicholas Baggett and Martin Garrett, for example, were chosen in 1596 to appraise the goods of Philip Joslyn for the city's Orphans Court.[104] At the other end of the scale, less illustrious practitioners of these crafts haave left a much greater footprint on the surviving documentation. The early seventeenth-century Somerset Quarter Sessions records, for example, show the regular examination of carpenters and joiners for a wide range of crimes including assault and threatening behaviour, drunkenness, the theft of sheep, tools and timber, wandering as a beggar or rogue, being of bad name and fathering a "base child" and, rather strangely, the theft of the lining of a pair of hose, belonging to one James Chubbe, which William Coggan of Crewkerne, a carpenter, insisted he had "found" on a footpath.[105]

None of these misdemeanours, however, matches the brazen antics in 1614 of Nicholas Smyth, apprentice to carpenter Hugh Gotherell of North Petherton.[106] Smyth was put out of service for having an affair with Gotherell's wife while Gotherell was away at work. He convinced her to run away with him to Bridgwater, where they went "from alehouse to alehouse and behaved themselves very lewdly". Smyth was caught and punished by caning but managed to escape. He then "haunted" the house of his master, living off his goods for three months while Gotherell was away working, before finally convincing

his master's wife to run away again. Mrs Gotherell took pans and platters with her, and even the feathers from her husband's bed, before Smyth was finally arrested and taken to Bridgwater.

While craftsmen at the lower social levels were regularly engaged in disputes and legal actions regarding their extra-curricular activities, it is very interesting to note that work-related disputes in the region seem to have been an infrequent occurrence. In other areas, the demarcation of the crafts and the efforts to which the various companies went jealously to defend their trade secrets and to prevent other trades from encroaching on their work led to regular, ongoing and often very costly disputes.[107] Certainly, the records of the London Plasterers Company are full of information regarding such disputes. The biggest threat to plasterers was from the trades that used some form of plaster in their own work, such as carpenters and particularly bricklayers and tilers, since it was very difficult to interpret clearly what constituted 'plastering work' or not. Disputes also arose between the plasterers and the painter-stainers, who, in London, found it difficult to enforce the terms of their charter against the plasterers, resulting in protracted and bitter disputes.[108]

There is very little evidence of these sorts of disputes in the West Country in this period. This, of course, may relate to the poor survival of Company records, or a less well developed guild system. On the other hand, it may simply be that working relationships were more cooperative and harmonious outside the capital. There is certainly some evidence that the work of various craftsmen overlapped in the sixteenth and seventeenth centuries. Painters, in particular, seem to have been real multi-taskers. Likewise, it seems that the region's plasterers could be involved in the work of other craftsmen. A sketchbook probably belonging to John Abbott, the seventeenth-century plasterer, contains detailed instructions for the preparation of oil and water-colour paints, specifically for use on canvas, wood, stone or metal – there is no mention of plaster. Plasterwork was rarely painted in this period, so, if the recipes were for his own use, John Abbott may have been not only a plasterer but also a decorative painter. It is telling that one of the only two known documents recording particular commissions to Abbott is for painted work and not just for plaster. The Frithelstock churchwardens' accounts for 1667 record a payment to John Abbott "for making of the King's Arms and writing in the Church and plastering of the Church and porch".[109]

Lace-making

A number of writers visiting Devon in the seventeenth century reported the existence of a significant lace-making industry. In 1630, Thomas Westcote wrote of Honiton: "here is abundance of bone-lace, a pretty toy".[110] Writing in 1669, Cosimo de Medici noted: "There is not a cottage in all the county nor that of Somerset, where white lace is not made in great quantities so that not only the whole kingdom is supplied with it but it is exported in great abundance".[111] While in 1698, Celia Fiennes wrote that in Honiton "they make the fine bone lace in imitation of the Antwerp and Flanders lace, and indeed I think it's as fine, it only will not wash so fine which must be a fault with the thread".[112]

This famous Devonshire lace later became known as 'Honiton lace', possibly because the finished product was transported from Honiton.[113] It was a bobbin lace, made using pairs of bobbins on to which fine threads were bound. The lace-maker pinned out a design on a lace pillow, and then plaited and twisted the threads from the bobbins to make motifs.[114] In the early days of lace-making the motifs were geometrical, but later, as fashions and techniques changed, flowers and leaves were incorporated into the designs.[115] This type of lace is also described as 'bone lace'. The derivation of the term is uncertain, but may relate to the use of bones at some stage in production. Whether this was bone bobbins or, as has been suggested, fish bones instead of pins, remains uncertain.[116]

Many explanations have been offered regarding the timing of, and influences on, the introduction of bobbin lace-making to Devon. A strong tradition associates the early development of the industry with Flemish refugees escaping the Alva persecutions (1568–77), but there is no firm evidence to support this idea.[117] Another suggestion is that the skill may have been introduced from Venice, since the city was the world leader in textile crafts and a major source of technical skill.[118] The evidence of pattern books suggests that Venice may even have been the original home of bobbin lace-making.[119]

While it is certainly likely that Continental knowledge and techniques influenced the development of the English industry, it also appears that early lace had home-grown roots, evolving from other types of embroidery, cutwork and drawn-thread work. Indeed, there is strong evidence of an earlier lace-making tradition in England.[120] In a Harleian manuscript of about 1471, for example, directions are given for the making of "lace bascon, lace indented, lace bordered, lace covert,

a brode lace, a round lace, a thynne lace, an open lace, lace for hattys". The manuscript opens with an illuminated initial, in which sits the figure of a woman making these articles.[121]

This needlework tradition was also an important part of Devon's sixteenth-century economy and society. The Exeter Orphan's Court Inventories show the prominence of needlework among the domestic possessions of the city's citizens, including tapestries, cushions, carpets, hats and various types of apparel embroidered with fashionable 'blackwork'. Some of these items were certainly produced locally. Among the debts owed in 1593 to Thomas Greenewoode, haberdasher, for example, was 21s. 6d. from "Nevell the Imbroderer".[122]

There is also evidence of earlier forms of lace-making in Devon. A number of Exeter inventories contain significant quantities of 'frame lace'. This was of a fairly high quality, being valued at between 18d. and 2s. for a single pound, and it seems to have been made locally; the inventories of Henry Maunder (1564) and John Follett (1589), both merchants, contain frames "for making lace".[123]

Frame lace, originally called 'lacis' or 'filet lace', is in fact one of the oldest types of lace – a form of decorative netting that may have derived at some point from the making of fishermen's nets. An early inventory from Exeter Cathedral suggests that as early as 1327 it possessed three pieces of darned netting for use at the altar and one for throwing over the desk.[124] Although it was an ancient craft, lacis techniques continued to develop in the sixteenth century. Queen Elizabeth possessed dozens of pieces of fashionable "networke", which decorated or covered doublets, overskirts, loose gowns, veils and cloaks, and a number of Italian pattern books emerged at the end of the sixteenth century which contained patterns for lacis.[125] These new styles were certainly known in England. William Barley's *A booke of curious and strange inventions*, printed in England in 1596, for example, contained lacis and needle lace patterns from Venice.[126]

The Devon bobbin or 'bone lace' industry, therefore, did not develop in a vacuum but within a well established tradition of needlework. Its emergence in east Devon was a natural progression given that conditions in the region were ripe to meet the demand for the new fashion. Honiton, in particular, was already a textile town, and had a well developed system of out-workers and merchants, as well as established trading links to London and its demand for finery.[127] All of these factors created a favourable set of conditions that only needed an initial impetus for the emergence and success of a bobbin lace industry.[128]

This impetus probably came in the latter part of the sixteenth century. To date, however, the earliest reference to the craft is an inscription on a tombstone in Honiton churchyard to James Rodge, bone-lace seller, who died 27 July 1617 and bequeathed to the poor of the parish the benefit of a hundred pounds. A similar bequest was made in the same year by Mrs Minifie, a lace-maker, so it is likely that both the lace dealer and the lace-maker carried on their business for a number of years before they died. Certainly Rodge's will shows that he had amassed a significant fortune by the time of his death.[129]

New evidence discovered in the Orphan's Court Inventories suggests that the craft was indeed practised in Devon, in some form, from at least 1576. In that year an inventory of the goods of William Seldon, a merchant of St Petrock, records "6 bobbings to winde silke upon", valued at 3d. While it is certainly possible that these bobbins could have had other functions, such as weaving or braid-making, the presence of "bobbinge lace" among the merchant's possessions is highly suggestive that these do in fact relate to the early incarnation of the industry. It is also notable that the inventory of John Follett, who, as noted above, was involved in the manufacture of frame lace, also had a significant amount of bone lace amongst his possessions. Nothing more is known about Follett, but he may have had some connection with Honiton, as three years after his death another John Follett, possibly his son, is listed in the inventories as being from "Honington".[130]

Bone lace in fact turns up frequently in the inventories for the late sixteenth century. Thomas Wythycomb, John Anthony and Thomas Martin, a fuller, all had quantities of it among their goods.[131] Although there is no firm evidence that this was locally produced, it is notable that while all imported Continental cloths and trimmings in the inventories are described by their place of origin – Naples silk, Bruges thread, Levant taffeta, etc. – bone lace is never found with such a description, suggesting that it was indeed of local origin. Perhaps also of note is the fact that in 1577 the churchwardens at Kilmington paid 12d. to have desk cloths made "with lacing about the same".[132]

It is difficult to establish the economic importance of the early bobbin lace industry in Devon. From the mid sixteenth century lace was a very fashionable item and was in high demand as a trimming and to produce collars, ruffs and cuffs, the edgings for handkerchiefs, shawls, tablecloths and bedspreads. It is generally assumed, however, that its use was limited to the elite in this period. Certainly, the re-enact-ment of sumptuary laws in Elizabethan England, designed to maintain

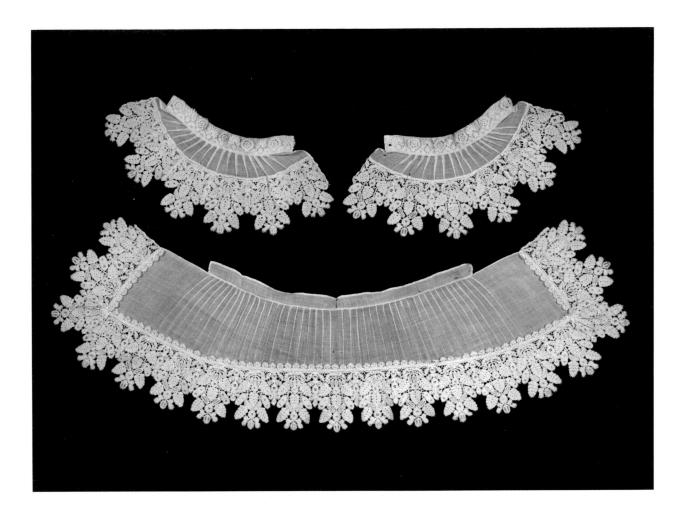

the distinction between the classes and to prevent the waste of money on frivolous luxuries, meant that even merchants and others who had wealth but lacked titles of nobility were strictly forbidden to wear all but the simplest of laces. Sumptuary laws, of course, were notoriously difficult to enforce, and were ignored more often than obeyed. In practice, there was a high demand in Devon for luxury lace among wealthy non-nobles. The inventory of John Antonye, in 1598, for example, contains gold lace, valued at 4s. per ounce, while a number of other inventories contain gold, silver, silk, velvet and crimson lace.[133]

Rather surprisingly, however, bobbin lace does not appear to have been a luxury item in its early days of production. In fact, it was relatively inexpensive. In 1611, Elizabeth Packett, a spinster from Honiton, admitted she had "found" bone-lace on a pillow at the house of Robert Searell which she took and sold for 6d.[134] Likewise, in the Exeter

inventories bone and bobbin lace are valued at between only 2d. and 9d. per yard, varying probably with quality and width. This was in stark contrast to the later century, when Honiton lace cost upwards of £1 per yard.[135] Even in 1637, when the Countess of Leicester was commissioned to buy English bobbin lace as a present for Anne of Austria, the French queen, she complained of the considerable expense.[136]

This may suggest that the Devon lace industry developed rapidly, with a massive improvement in technique and quality between the late sixteenth and mid seventeenth centuries. The lace of the Elizabethan period may have borne little resemblance to the fine Honiton lace that became famous later and may have been more closely related to older types of braiding and weaving. This form of bone lace may have functioned, before its later evolution, as an affordable alternative for the less well off, who were just as fond of clothing trimmings in this period as the elites. At 2d. per yard, for example, local bone lace would have been affordable for a skilled worker, such as a mason or carpenter, who earned between 10d. and 14d. for a day's work.[137]

Whether or not less affluent people wore bobbin lace in the sixteenth century, they were certainly involved in producing it. The organization of this industry was markedly different to the other decorative arts in the period. Lace-making was a cottage industry and the vast majority was made in the homes of workers. These workers were not independent artisans but were controlled by shop owners and entrepreneurial merchants, who employed teams to produce lace for sale in London and other markets.[138] In this system, the merchant capitalist was usually the master of the production process. He owned the raw materials, coordinated the manufacturing process and sold the finished product.[139] There is evidence, however, that women sometimes operated as hucksters – petty retailers who sold in the streets or rented stalls in towns, perhaps to supplement their income. In a case heard at the Quarter Sessions Court in 1621, for example, a girl from Sidmouth was sent to Honiton market by her mother to sell four pieces of lace. She sold these from her basket, which she set down on a bench in someone's house.[140]

Lace-makers were often the wives of poorly paid labourers, but children too were commonly employed.[141] Child labour was crucial to the survival of poor families in the sixteenth and seventeenth centuries. A petition at Somerset's Quarter Session Court in 1620, by Joane Harvey of Yeovil, stated that she had agreed with Barbara, the wife of John Gaylord of Montague, that she would teach three of her children the trade of bone lace and pay for their upkeep, but Barbara withdrew the

children before the end of the year.[142] Likewise, a petition to the assizes at Exeter Castle in 1638 notes local concern about the influx of poor migrants to Honiton to service the bone-lace industry and states that any master in any other parish who takes a child as an apprentice cannot later place the child in Honiton without consent from the justices.[143]

There was also a strong link between lace-making and charity in this period. Lace was in high demand and, given the amount of labour required to produce it, it is likely that in the early days of commercial production demand far outstripped supply. The basic tools of the industry, however, were fairly cheap and easy to obtain and, as a result, in many regions it became customary to require residents of alms houses, orphanages and other charitable institutions to learn the craft.[144] Lace making was seen as suitable employment for the poor, and the sale of their output could be used to defray the cost of their care. This association is very clear from West Country evidence. An early apprenticeship indenture, dated 1606, shows that Katherine Waters, an orphan from Gloucester, was given as an apprentice, "with the consent of the parishioners of Northweeke", to Richard Yarrett of Bristol, cooper, and Jane his wife "to learn the art of making bone lace from Jane".[145] In this case, lace-making became part of a fostering relationship. Likewise, the memorial of John Rodge, the bone-ace dealer, bears a stark warning to the living to *Remember the poore*.

Conclusion

The limitations of the source material mean that the West Country's master craftsmen will always remain rather shadowy figures. What is clear, however, is that the sixteenth century was a period of dramatic change and development in the region's decorative arts. The impact of major social, cultural and economic developments sweeping the nation were keenly felt in the West Country and played a significant role in driving demand for the arts and in stimulating new fashions and tastes.

Growing trade networks, immigration and the development of print culture in this period meant that, although geographically distant from the centre of fashion in London, local patrons and artists were dynamically in tune with outside changes in style and technique. Indeed, the survival of regional decorative artwork shows that they were confident enough to interpret emerging trends in an independent and unique way, influenced both by the availability of local raw materials and the conscious fusion of local vernacular and Continental styles.

Documentary and material evidence suggests that the region was a major centre for production and training in a number of the decorative arts. With regards to decorative plasterwork, for example, the South West appears to have been second only to London as a training centre. Indeed, in terms of the lace-making industry, Devon probably led the way in this period, with local sources showing that bone lace was produced commercially in the region from at least the last quarter of the sixteenth century, if not before.

Overall, the sixteenth century was a vibrant time for the region's arts and crafts, and this brief survey shows without doubt the value of extending our focus of interest in the decorative arts beyond London, to develop a richer and more complete picture of the evolution of English styles and techniques during this period.

NOTES

Abbreviations used in footnote references: BL British Library; BRO Bristol Record Office; CRO Cornwall Record Office; DRO Devon Record Office; NDRO North Devon Record Office; PCC Prerogative Court of Canterbury; SRO Somerset Record Office; TNA The National Archives.

1 Cited by J.T. Fouracre in 'Ornamental lime-plaster ceilings and the plasterers craft in Devon', *Transactions of the Devonshire Association*, 1909, p. 260.

2 See Colin Platt, *The English Medieval Town*, London: Secker & Warburg, 1976; Timothy Kent, *West Country Silver Spoons and their Makers, 1550–1750*, London: J.H.Bourdon-Smith, 1992, p. 1; for a recent analysis of the West Country trade, see D. Taylor, 'The Maritime Trade of the Smaller Bristol Channel Ports in the Sixteenth Century', PhD thesis, University of Bristol, 2009.

3 It has been suggested that the Garrets, a notable family of Exeter joiners, were of Dutch origin. See Anthony Wells-Cole, 'An Oak Bed at Montacute: A Study in Mannerist Decoration', *Furniture History*, 1981, p. 8; see also John Allan, 'Immigrant Craftsmen in South-West England, 1500–1550', in P.E. Pope and S. Lewis-Simpson (eds.), *Exploring New World Transitions: From Seasonal Presence to Permanent Settlement*, forthcoming.

4 For a detailed discussion, see Wells-Cole, 'An Oak Bed at Montacute'.

5 The house was built for Sir Thomas Drewe c. 1619. The panelling was removed in the 1920s and installed in the Speed Art Museum, Kentucky, in 1944.

6 See Anthony Wells-Cole, *Art and Decoration in Elizabethan and Jacobean England, The Influence of Continental Prints, 1558–1625*, New Haven and London: Yale University Press, 1997.

7 Bradninch Manor, for example.

8 The jug itself was made at Frechen, near Cologne.

9 This column may have formed part of a staircase newel post or the external decoration of a house.

10 The column is now in the Victoria and Albert Museum, London.

11 Christine Faunch, 'Church Monuments and Commemoration in Devon, c. 1530–c. 1640: Volume II', PhD thesis, University of Exeter, 1998, p. 386.

12 *Ibid.* Two effigies to the Poulett family, made out of Devon Beer-stone, contain very similar decoration, blending Gothic and Renaissance motifs. These were possibly carved in Exeter or by an Exeter mason and then moved to Somerset to be completed using local stone. See Faunch, 'Church Monuments and Commemoration', I, p. 51. See also A.C. Fryer, 'Monumental Effigies in Somerset', *Proceedings of the Somerset Archaeological and Natural History Society*, 7, 1928; Bridget Cherry and Nikolaus Pevsner, *Devon*, London: Penguin Books, 1989.

13 See Faunch, 'Church Monuments and Commemoration', I, p. 51.

14 Nigel Saul, *English Church Monuments in the Middle Ages: History and Representation*, Cambridge: Cambridge University Press, 2009; Peter Sherlock, *Monuments and Memory in Early Modern England*, Aldershot: Ashgate, 2008.

15 Faunch, 'Church Monuments and Commemoration', I, p. 50.

16 A pageant in this context was probably a tapestry or hanging covered with narrative or decorative religious scenes, or a wooden or alabaster figure. See Robert Dymond, *The*

History of the Parish of St. Petrocks, Exeter, as shown by its Churchwardens accounts and other records, Transactions of the Devonshire Association for the Advancement of Science, Literature and Art, vol. 14; reprinted from *Transactions of the Devonshire Association*, 1882, vol. 14, pp. 57–59.

17 Eamon Duffy, *The Voices of Morebath: Reformation and Rebellion in an English Village*, New Haven and London: Yale University Press, 2001, p. 178.

18 Kilmington Churchwarden Records: www.archive.org/stream/cu31924028138406#page/n13/mode/2up.

19 Duffy, *Voices of Morebath*, p. 178.

20 Timothy Kent, *West Country Silver Spoons and their Makers*, London: J.H.Bourdon-Smith, 1992, p. 111.

21 Tax assessments can be used roughly to compare the relative wealth of goldsmiths. Christopher Easton was assessed in 1595 and 1602 at £4 and £3 respectively; John Eades was assessed in 1602 at £5 in goods; Thomas Mathew's assessments were £5 (1571), £10 (1582), and £3 (1592): TNA E/179/100/388; TNA E/179/100/372; TNA E/179/100/385 (*Devon and Cornwall Record Society, New Series*, vol. 22, 1977, pp. 61–73). Wills also show the relative wealth of goldsmiths. John Jones, for example, disposed of a large estate with property: PCC 32 BUTTS.

22 PCC 32 BUTTS.

23 Kent, *West Country Silver Spoons*, p. 38.

24 For a detailed breakdown of freight expenses, see Blaylock, 'Exeter Guildhall', pp. 142–46; See also Faunch, 'Church Monuments', I, pp. 28–33, 52.

25 Faunch, 'Church Monuments and Commemoration', I, pp. 28–33. Beer stone was favoured for high-quality carving. It travelled much further, and was employed in London and south-east England. For example it was used at Old Thorndon Hall, Essex; Petworth, Sussex; Hatfield, Herts, and possibly Salisbury House, London. See Malcolm Airs, *The Tudor & Jacobean Country House: A Building History*, Godalming: Sutton Publishing, 1998, pp. 99, 107–112.

26 Alice C. Bizley, *The Slate Figures of Cornwall*, Perranporth: Worden Press, 1965. See also P.D. Cockerham, 'Continuity and Change: Memorialisation and the Cornish Funeral Monument Industry, 1497–1660', PhD thesis, University of Exeter, 2003.

27 Faunch, 'Church Monuments and Commemmoration', I, pp. 28–33.

28 Duffy, *Voices of Morebath*, p. 178.

29 *The Parish of Ashburton: The 15th and 16th Centuries: As It Appears from Extracts from the Churchwardens' Accounts, A.D. 1479–1580*, London, 1870, p. 41.

30 Many thanks to Roderick Butler and Polly Legg of the Regional Furniture Society, and to Shaw Edwards Antiques, for providing me with their expertise in this area.

31 Paul Fitzsimmons, 'Discovering Dennis: The Search for Thomas Dennis Among the Artisans of Exeter', Morwenna Photography for Maramchurch Antiques, 2009.

32 BL Harleian MS 5827, 'Synopsis Chorographical of Devonshire', fols. 3–5.

33 NDRO 50/11/17/3.

34 DRO 123M/L32; see also DD\X\RMN/3 1577, 'Deeds of land at Old Cleeve etc., held by the Hayman family': "Suit of court at Old Cleeve twice a year; mill suit to the Abbey mill tenants to maintain premises; to take timber only for repairs; lops and tops for firing; no oak, ash or elm to be cut for fuel except starveling or hollow trees".

35 For an introduction to the debate on the so called 'Great Re-building', see W.G. Hoskins, 'The Rebuilding of Rural England, 1570–1640', *Past and Present*, 4, 1953, pp. 44–59; R. Machin, 'The Great Rebuilding: A Reassessment', *Past and Present*, 77/1, 1977, pp. 33–56; M.H. Johnson, 'Rethinking the Great Rebuilding', *Oxford Journal of Archaeology*, 12, 1993, pp. 117–25.

36 John Hatcher, *The History of the British Coal Industry: Before 1700*, 5 vols., Oxford: Oxford University Press, 1993, I, pp. 31–40; Oliver Rackham, *Trees and Woodland in the British*

Landscape, London: J.M. Dent & Sons, 1976, p. 92; John Nef, *The Rise of the British Coal Industry*, London: George Routledge & Sons, 1932, I, pp. 156–64, and T.S. Ashton, *Iron and Steel in the Industrial Revolution*, Manchester: Manchester University Press, 1924; R.C. Allen, 'Was There a Timber Crisis in Early Modern Europe?', in S. Cavaciocchi (ed.), *Economia e energia secc. XIII–XVIII*, Istituto Internazionale di Storia Economica 'F. Datini', Florence: Le Monnier, 2003.

37 Thanks to Andrew Hennell Antiques of Woodstock for confirming re-use of oak in furniture produced in other regions of England.

38 Prolific, highly skilled and successful craftsmen are particularly associated with Exeter and Barnstaple in this period: see Kent, *West Country Silver Spoons*, pp. 1–4. Bristol, Salisbury and Taunton have also been identified as significant areas of production.

39 J.F. Chanter, 'The Exeter Goldsmiths Guild', *Transactions of the Devonshire Association*, 1912, vol. 44, pp. 443–44; Kent, *West Country Silver Spoons*, pp. 33–43.

40 An example of the way goldsmiths might defraud customers is found in the Somerset Quarter Sessions Records in 1622, when James Rawlins of [Barton St] David, husbandman, gave information concerning George Gallop of West Lydford, gent., telling him about the washing of metal and the making of red metal, which a goldsmith declared was gold: SRO Q/SR/42/160.

41 John F. Cherry, *Goldsmiths*, London and Toronto: University of Toronto Press, 1992, p. 53.

42 Oath reproduced in full in Kent, *West Country Silver Spoons*, p. 33.

43 Kent, *West Country Silver Spoons*, p. 34. The purity of gold was determined by a touchstone, a small piece of black rock. This was rubbed on the surface of the object to produce a streak, which was then compared with other alloys of known composition. Gold, silver and gems were also weighed using a scale. Goldsmiths' scales had to be regularly sized and standardized as even fractional differences could mean heavy loss or profit.

44 Kent, *West Country Silver Spoons*, p. 34.

45 Goldsmith Company Minute Book K, p. 162.

46 Goldsmith Company Minute Book L, p. 76; see also Kent, *West Country Silver Spoons*, pp. 34–36; in Barnstaple, Thomas Mathew, John Cotton, Simon Hill and Richard Diamond were all fined. In Exeter Henry Hardwycke, Steven More, Philip Dryver, Richard Bullyn, John Northe and Richard Osborne were also fined.

47 Richard Hilliard and Thomas Mathew, for example, placed their sons with London masters. Interesting is the case of William Cotton, an Exeter goldsmith who placed his son with Robert Trappis in London. Trappis (c. 1479–1560) was a prominent member of the Goldsmiths' Company, twice Prime Warden and an Alderman. When Cotton senior died, Trappis held the son's inheritance in trust. There was an ensuing legal battle when Cotton junior pursued his mother, who had since married another goldsmith, Peter Strech, for his inheritance. Trappis later sold the apprenticeship to Strech for £46. See TNA C 1/911/37-40.

48 http://www.thegoldsmiths.co.uk/collections-library/library/company-archives/a-history-of-the-goldsmiths'-company/.

49 Kent, *West Country Silver Spoons*, p. 71.

50 J.F. Chanter, 'The Barnstaple Goldsmiths' Guild', *Report and Transactions of the Devonshire Association for the Advancement of Science, Literature, and Art*, 49, 1917, p. 175.

51 https://www.familysearch.org/learn/wiki/en/Apprenticeship_in_England.

52 SRO D/B/bw/854.

53 TNA Prob/11/46.

54 John Jones bequeathed £20 to the poor: PCC 32 BUTTS; Hilliard 20s.: TNA PROB/11/84; John Walker left an interest-free loan to help young men in their careers: TNA PROB/11/46.

55 The merchants received a grant of incorporation in 1588–89, which forbad all inhabitants of Exeter who were not members of the society to sell any goods produced outside the realm or to export goods beyond the seas. This went far towards concentrating a great

part of the commercial activity of the city in the hands of company members. The provision provoked a bitter civic feud, the details of which were preserved by John Hooker, who played a prominent role in the events. The documents include copies of petitions and replications sent to London and depositions taken by magistrates. Hilliard was one of the representatives of the complainants and had a role as deputy in the negotiations. See Wallace T. MacCaffrey, *Exeter 1540-1640: the Growth of an English Town,* Cambridge, Mass.: Harvard University Press, 1978, pp. 136–49; DRO ECM, Book 85.

56 There exists an 'IOU' from Sir William Kirkham of Blagdon, Paignton, to Christopher Easton for £10 10s. in payment for three gilt bowls: SRO DD/WO/53/5/8.

57 Mark Dawson, *Plenti and Grase: Food and Drink in a Sixteenth-Century Household,* Totnes: Prospect Books, 2009, p. 213.

58 Kent, *West Country Silver Spoons,* p. 60.

59 Beth Carver Wees, *English, Irish and Scottish Silver at the Sterling and Francine Clark Art Institute,* Williamstown: Hudson Hills Press, 1997, p. 119.

60 One such custom was observed at Corporation dinners in Lichfield, England, where the two toasts, "The Queen" and "Weale and Worship", were drunk from a massive embossed silver cup. An account by a correspondent in a contribution to *Notes and Queries* noted that "The Mayor drinks first and, on his rising, the persons on his right and left also rise. He then hands the cup to the person on his right when the one next to him rises, the one on the left of the Mayor still standing. Then the cup is passed across the table to him when *his* left hand neighbour rises; so that, there are always three standing at the same time." See Robert Chambers (ed.), *The book of days, a miscellany of popular antiquities in connection with the calendar, including anecdote, biography, & history, curiosities of literature and oddities of human life and character* [1863–64], London and Edinburgh: W. & R. Chambers, II, 1906, p. 531; Edward Wenham, 'English Standing Cups', *American Collector,* February 1947, http://www.collectorsweekly.com/articles/english-standing-cups/.

61 DRO, Orphans Court Inventories, 26.

62 W.J. Cripps, *Old English Plate: Ecclesiastical, Decorative, and Domestic: its Makers and Marks,* Michigan: Murray, 1894, p. 281.

63 Philippa Glanville, *Silver in Tudor and Early Stuart England,* London: Victoria and Albert Publications, 1990, pp. 330–37; Estienne Perlin, *Description Des Royaulmes D'Andleterre Et D'Escrosse,* Paris, 1558.

64 For a discussion of the Exeter evidence relating to these stonewares, including their origins and transport, the different forms of mount and their usage in different Exeter rooms, see J.P. Allan, *Medieval and Post-Medieval Finds from Exeter,* Exeter: University of Exeter Press, 1984, pp. 117–25.

65 David Gaimster, *German Stoneware 1200–1900: Archaeology and Cultural History,* London: British Museum Press, 1997; http://www.sothebys.com/app/live/lot/LotDetail.jsp?lot_id=3WS8N.

66 In London goldsmith's shops were usually in the Goldsmiths Quarters and Cheapside was London's centre. See Cherry, *Goldsmiths,* p. 69.

67 Kent, *West Country Silver Spoons,* p. 57.

68 Cherry, *Goldsmiths,* p. 69, notes that shops in Cheapside were about 2 m wide and 3 m deep, which is similar to William Cotton's shop. He does not state his source for these dimensions.

69 *Ibid.*

70 Mayors Court Book, 1613.

71 DRO, Orphans Court Inventories, 26

72 DRO, Orphans Court Inventories, 23.

73 T. Kent, 'Spoon-makers' Sources of Supply – A Review', *The Finial,* 2003.

74 CRO ME/2488.

75 Kent, *West Country Silver Spoons,* p. 14.

76 John Thorp, 'Wall-painting and Lime-Plaster Decoration', in Peter Beacham (ed.), *Devon Building: An Introduction to Local Traditions*, Tiverton: Devon Books, 1990, pp. 129–49.

77 K. and C. French, 'Devonshire Plasterwork', *Transactions of the Devonshire Association*, 1957, vol. 89, p. 127; Thorp, 'Wall- painting', p. 134.

78 Thorp, 'Wall-painting', p. 134.

79 *Ibid.*, p. 131.

80 *Ibid.*

81 *Ibid.*

82 A number of historians have repeated the idea that John Abbott was the son of Richard Abbott and grandson of John Abbott, both plasterers. In fact, Abbott's genealogy is so confusing that it is impossible to be sure who his father was, and there is certainly no evidence that he was also a plasterer. An example of the confusion surrounding the Abbotts is the Frenches' claim ('Devonshire Plasterwork') that John Abbott of Frithelstock was descended from William Abbott, Henry VIII's Serjeant of the Cellar, who was granted the dissolved abbey of Hartland by Henry VIII, one of whose 'many' sons then moved to Frithelstock. This William Abbott had no sons at all. See Heralds Visitation Records: http://contentdm.lib.byu.edu/cdm4/document.php?CISOROOT=/FHMedieval&CISOPTR=441&CISOSHOW=0.

83 French, 'Devonshire Plasterwork', p. 127.

84 Thorp, 'Wall-painting', p. 136.

85 Claire Gapper, 'Decorative Plasterwork in City, Court and Country 1530–1660', PhD thesis, University of London, 1998; http://www.clairegapper.info/4.html.

86 *Ibid.*

87 Wells-Cole, 'An Oak Bed', p. 8. The Garrett and Hermon surnames were interchangeable: see, for example, DRO Orphans Court Inventory 61 (5 June 1596).

88 Wells-Cole, 'An Oak Bed', p. 8. The Exeter subsidy assessment of 1602 assessed him at £3 3s., which was quite a significant amount of money: R. Dymond, *The History of the Parish of St Petrock, Exeter, as shown by its Churchwardens' Accounts and Other Records* (1882), p. 66.

89 DRO RAB 1593–4, fol. 12v. Payment was made in February 1594, but the door bears the date 1593 and the ironwork had been purchased several months earlier. See Blaylock, 'Exeter Guildhall', p. 142.

90 DRO CAB 5, 228.

91 Blaylock, 'Exeter Guildhall', p. 141; Faunch, 'Church Monuments and Commemoration', p. 54.

92 Faunch, 'Church Monuments and Commemoration', p. 55.

93 Including the Gilbert and Carew monuments in Exeter Cathedral, the Drewe monument at Broadclyst, the Wykes monument at South Tawton, the Bamfylde monument, those of Giffard at Tiverton, the Courtenays at Chudleigh and Joan Wadham and Elias Holcombe at Branscombe, the Fortescue monument at East Allington, the Woolton tablet in Exeter Cathedral, the Godwin tablet in the Cathedral; the Wadham tablet. For a detailed discussion see Faunch, 'Church Monuments and Commemoration', pp. 52–54. Other potential masons responsible include John Newell, William Hewes, George Pester, William Laurence, John Ellacombe, all of whom obtained the freedom of the city between 1574 and 1608.

94 DRO Orphans Court Inventories, 48.

95 For example, in Tavistock (1566–67), Colyn the joiner was paid 2s. 6d. for three days' work on the floor of the market house and Joseph Palmer was paid 2s. 3d. for two days working on the same project. Tavistock records are available at http://www.archive.org/stream/calendaroftavistoowort/calendaroftavistoowort_djvu.txt.

96 In Tavistock George Fisher was given meat and drink in addition to his payment for work on the Sepulchre (1543–44). Sometimes payment for minor tasks was given entirely in food and drink, as in Ashburton (1555–56), when the carpenters were given 6d.-worth of

bread and drink for "measuring the timber on holy rood day": see *The Parish of Ashburton in the 15th and 16th Centuries; as it appears from extracts from the churchwarden's accounts, A.D. (1479–1580) with notes and comments,* p. 35.

97 Patton Churchwarden's Accounts, 1454; http://www.archive.org/detailschurchwardens accoohobhrich.

98 *Ibid.*, p. 79.

99 J.E. Binney (ed.), *The Accounts of the Wardens of the Parish of Morebath, Devon 1520–1573,* Exeter: James G. Commin, 1904, p. 70; Duffy, *Voices of Morebath,* p. 78.

100 *Ibid.*

101 Duffy, *Voices of Morebath,* p. 78.

102 A press in this context is "a large (usually shelved) cupboard, esp. one placed in a recess in the wall, for holding linen, clothes, books, etc., or food, plates, dishes, and other kitchen items" (OED). A wimble is an instrument used to bore holes.

103 DRO Orphans Court Inventory, 60.

104 DRO Orphans Court Inventory, 60.

105 SRO Q/SR/18/117–18 (1613); Q/SR/29/46 (1618); Q/SR/31/14; Q/SR/6/106; Q/SR/9/28–29; Q/SR/17/80–81; Q/SR/18/54–55; Q/SR/23/5 (1616); Q/SR/23/29 (1616); Q/SR/29/70; Q/SR/32/80; SRO Q/SR/29/46.

106 SRO Q/SR/19/35 (1614).

107 See for example, H.J. Louw, 'Demarcation Disputes between the English Carpenters and Joiners from the Sixteenth to the Eighteenth Century', *Construction History,* 5, 1989, pp. 3–20; Gapper, 'Decorative Plasterwork', Ch. III.

108 For detailed discussion, see Gapper, 'Decorative Plasterwork', Ch. III.

109 Michael Bath, 'The Sources of John Abbott's Pattern Book', *Architectural History,* 41, 1998, p. 55.

110 Thomas Westcote, *A View of Devonshire in MDCXXX,* Exeter, 1845.

111 Travels of Cosmo the Third, Grand Duke of Tuscany, through England, during the reign of Charles the Second (1669): http://www.archive.org/details/travelsofcosmo thoomagarich.

112 C. Fiennes, *Through England on a Side Saddle in the Time of William and Mary,* London: Field and Tuer, The Leadenhall Press, 1888: http://www.visionofbritain.org.uk/text/chap_page.jsp?t_id=Fiennes&c_id=3

113 H.J. Yallop, *The History of the Honiton Lace Industry,* Exeter: University of Exeter Press, 1992, p. 32.

114 P.M. Inder, *Honiton Lace,* Exeter: Royal Albert Memorial Museum, 1985, p. 1.

115 http://www.laceguild.demon.co.uk/craft/history.html.

116 Inder, *Honiton Lace,* p. 1.

117 For a detailed discussion, see Yallop, *History of Honiton Lace,* pp. 12–26, and Pamela Sharpe, *Population and Society in an East Devon Parish: Reproducing Colyton, 1540–1840,* Exeter: University of Exeter Press, 2002, p. 92. See also, for example, J.R.W. Coxhead, *The Romance of the Wool, Lace and Pottery Trades in Honiton,* Honiton: Mrs P.H. Thrower, 1952, p. 23; W. Cunningham, *Alien Immigrants to England,* London: S. Sonnenschein & Co., 1897, p. 177; A. Dryden, 'Honiton lace', in F.J. Snell (ed.), *Memorials of Old Devonshire,* London: Bemrose, 1904, p. 239; Inder, *Honiton Lace,* p. 2; B. Palliser, *A History of Lace,* London: Sampson Low, Son, & Marston, 1865, p. 373; Samuel Smiles, *The Huguenots: Their Settlements, Churches and Industries in England and Ireland,* London: Murray, 1880, p. 110.

118 Yallop, *History of Honiton Lace,* p. 22; Sharpe, *Population and Society,* p. 92; Santina M. Levey and Patricia C. Payne, *Le Pompe 1559 Patterns for Venetian Bobbin Lace,* Bedford: Ruth Bean Publishers, 1983, p. 9; L.B. Casanova, 'Venice and her Lagoon', in Doretta Davanzo Poli (ed.), *Cinque secoli di merletti europei: I capolavori,* Burano: Consorzio Merletti di Burano, 1984, p. 15.

119 Yallop, *History of Honiton Lace,* p. 22.

120 Sharpe, *Population and Society*, p. 92.

121 B.L Harleian MS 2320.

122 DRO Orphans Court Inventories, 51.

123 DRO Orphans Court Inventories, 2a and 40a.

124 M. Jourdain, 'Drawn Thread Work and Lacis', *The Connoisseur*, 10, 1904.

125 F. Vinciolo, *Les Singuliers et Nouveaux Pourtaicts*, Paris, 1587; Elizabetta Catenea Parasole, *Pretiosa gemma delle virtuose donne*, Rome, 1598.

126 A booke of curious and strange inuentions, called the first part of needleworkes containing many singuler and fine sortes of cut-workes, raisde-workes, stiches, and open cutworke, verie easie to be learned by the dilligent practisers, that shall follow the direction herein contained. Newlie augmented: First imprinted in Venice. And now againe newly printed in more exquisite sort for the profit and delight of the gentlewomen of England [by J. Danter] For William Barley, 1596: BL STC (2nd ed.) / 5323a.8.

127 Yallop, *History of Honiton Lace*, p. 20.

128 *Ibid.*, p. 21.

129 TNA PROB 11/130.

130 DRO Orphans Court Inventories, 52.

131 DRO Orphans Court Inventories, 63, 78 and 72.

132 http://archive.org/details/cu31924028138406.

133 DRO Orphans Court Inventories, 72.

134 DRO QSBb Midsummer 1611.

135 Yallop, *History of Honiton Lace*, p. 59.

136 http://collections.vam.ac.uk/item/O77374/collar/.

137 R.N. Worth FGS, *Calendar of Tavistock Parish Records* [1887], Axminster: Richardson, 2009.

138 http://www.honitonmuseum.org/index.php?page=lace-making.

139 Keith Wrightson, *Earthly Necessities: Economic Lives in Early Modern Britain, 1470–1750*, New Haven and London: Yale University Press, 2000.

140 DRO QSBb Epiphany 1621; Marjorie Keniston McIntosh, *Working Women in English Society, 1300–1620*, Cambridge: Cambridge University Press, 2005.

141 BRO P.Xch/OP/4 1606 May 28.

142 SRO Q/SR/35/150.

143 Sharpe, *Population and Society*, p. 96.

144 *Ibid.*, p. 94.

145 BRO P.Xch/OP/4 (earliest known indenture).

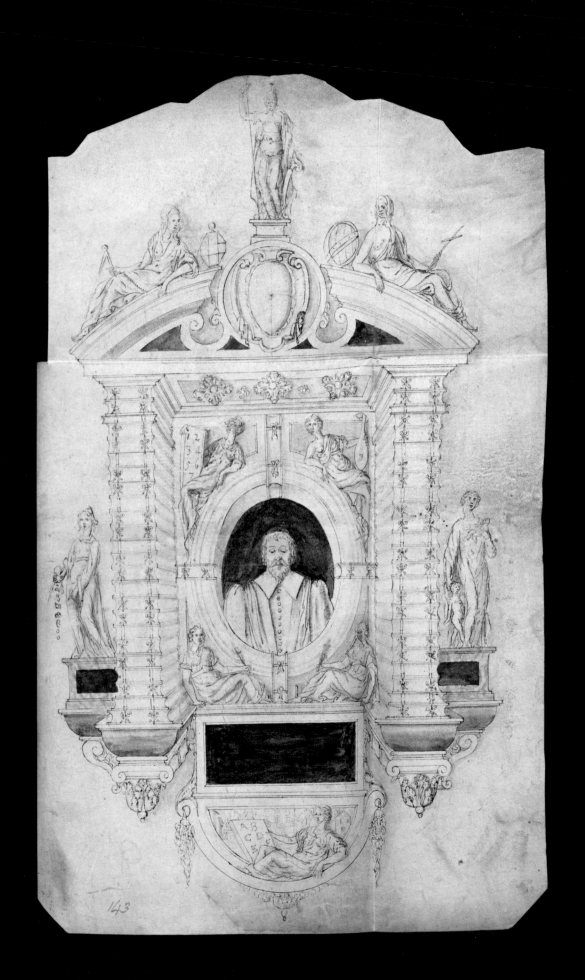

ART IN BRITAIN
BETWEEN 1530 & 1620

Karen Hearn

THE WORKS IN THE PRESENT EXHIBITION span the eventful reigns of Henry VIII (1509–47), those of his children – Edward VI (1547–53), Mary I (1553–58), Elizabeth I (1558–1603) – and of Elizabeth's successor James VI of Scotland, who ascended the throne of England as King James I in 1603.

The introduction of the Protestant Reformation to England in the 1530s, with its increasingly hard-line response to the display of religious pictures or sculpture – in a re-interpretation of the Second Commandment's ban on worshipping images – meant that most of the English paintings that have survived from this period are portraits. Indeed, English Protestants seem generally to have found portraiture an acceptable form of image, since it fulfilled many practical functions. Portraits could mark a major career or life event, such as inheriting or gaining an estate or a title, or an appointment to an important post. They could record the features of family members, convey the appearance of a potential spouse, or enable one to display allegiance to the monarch or to a political patron.

Unlike the position in the countries on the Continent that remained Catholic, almost no English religious paintings from this period are extant – most English religious visual material having been destroyed in the sixteenth or seventeenth centuries, in a practice termed 'iconoclasm'. Thus the sculpture workshops that had previously carved religious figures, generally from alabaster, either ceased production or concentrated on making funerary monuments. By the end of the sixteenth century, the most fashionable monument-makers were Netherlanders, based in the London parish of Southwark. Even the main English exponent who rivalled and succeeded them in London, Nicholas Stone (1586/87–1647), who was born at Woodbury, the son of a quarryman, trained partly in Amsterdam (cat. 11).

11

Nicholas Stone, *Design for Thomas Bodley's Monument*, 1613–15, ink and wash on parchment © The Bodleian Library, University of Oxford, MS. Ashmole 1137

Indeed, throughout the period in question, the leading painters to the English elite – particularly to the Court – seem to have been migrants, who had been born and trained overseas. The most important of these was the German Hans Holbein II, who worked in London from 1527 to 1529 and again from 1533 until his death there in 1543.[1] Holbein produced innovatory images of Henry VIII and of members of his court, including the painting of the Cornishman *William Reskimer* (cat. 13). Holbein's method of working was first to produce a portrait drawing from the life and then, by tracing, to transfer its outlines to the prepared surface of a wooden panel, thus making it the basis for a resulting painting.[2] Such drawings could then also be used by painters assisting in Holbein's studio, or copied or traced by others outside it, to make further portraits – even well after Holbein's death, as in the posthumous portrait of George Carew (cat. 12), who drowned in his command, the *Mary Rose*, in the Battle of the Solent (1545).

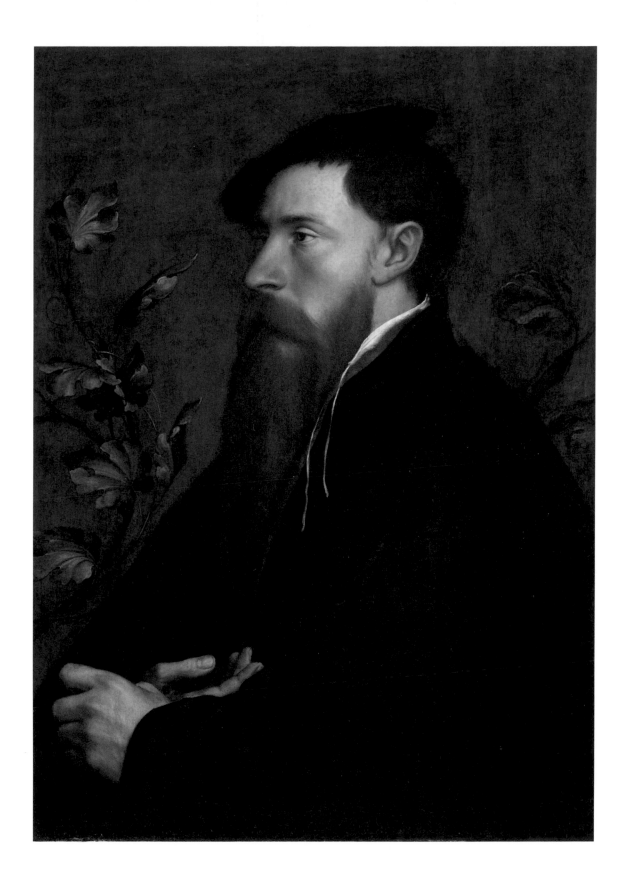

Unknown artist, *Queen Elizabeth I ('The Armada Portrait')*, c. 1588, oil on panel © Tyrwhitt-Drake Collection

After her accession in 1558, Elizabeth I and her advisers appear to have made various attempts to control the production of portraits of her. Although many images of Elizabeth survive from throughout her long life, very few are by artists who can today be identified. In 1581 George Gower (died 1596) was appointed her Serjeant Painter, and his name appears in the royal financial accounts for decorative and heraldic painting projects from 1581 to 1596. In 1584 a draft patent – apparently not enacted – would have granted Gower the monopoly to produce all painted and engraved portraits of the queen, with the exception that the miniatures of her would be made by the Devon-born Nicholas Hilliard (see the following essay). Nevertheless, it has not proved pos-sible to identify any portrait of her as definitely being by Gower, and indeed very few other works as by him either. Morcover, some images of Elizabeth – particularly ones that associated her with England's repulsion of the Spanish Armada in 1588 (see cat. 14) – were even produced during the reign of her successor, James I.

In fact, because it was extremely rare for painters working in England during the sixteenth and early seventeenth centuries to sign their works, most of the portraits that survive from that time cannot be attributed to specific artists (see, for example, cat. 15). Few corrobo-rating documents relate to paintings and, in London, the records of the relevant guild, the London Painter-Stainers Company, barely survive from before the 1620s. Recent technical investigations confirm that many paintings were the work of more than one hand, and that English studios operated in the collaborative manner found also in artists' workshops on the Continent.[3]

From the start of the 1590s, the full-length format became popular for portraits in England (see cat. 15). While large-scale paintings had previously been executed on wooden panel, canvas now became the favoured support, which meant that portraits could become much larger and, in some cases, ostentatious. The leading portraitist during the final decade of Elizabeth I's reign was the second-generation migrant Marcus Gheeraerts II (1561/62–1636), who had been brought to England by his artist father Marcus Gheeraerts I as a Protestant exile fleeing religious persecution in Bruges in the Southern Netherlands in 1568. He is thought to have painted Sir Frances Drake in 1591 (see fig. 15) and his most celebrated work is probably the so-called 'Ditchley' full-length portrait of the elderly Elizabeth I, made in about 1592 for Gheeraerts's patron Sir Henry Lee, who had formerly been her official Champion.

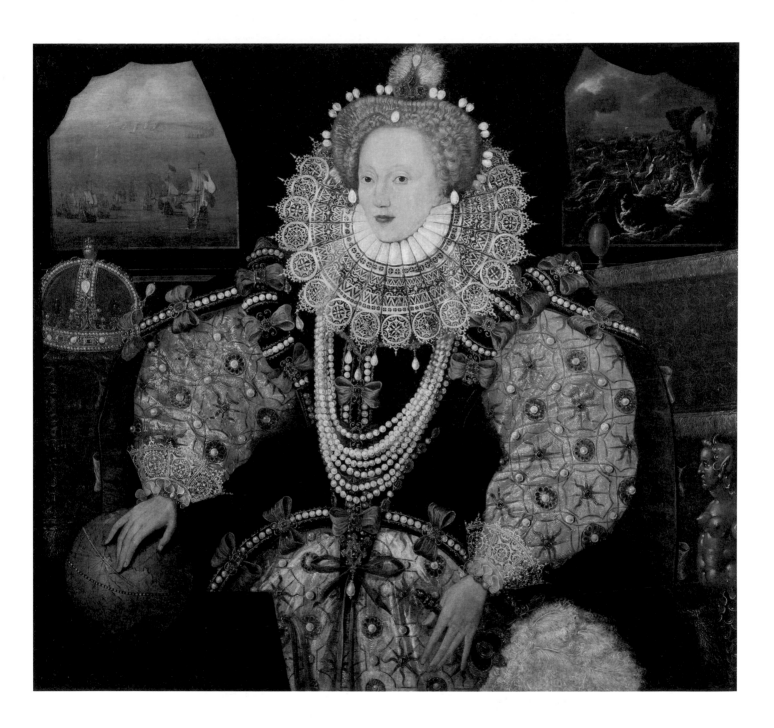

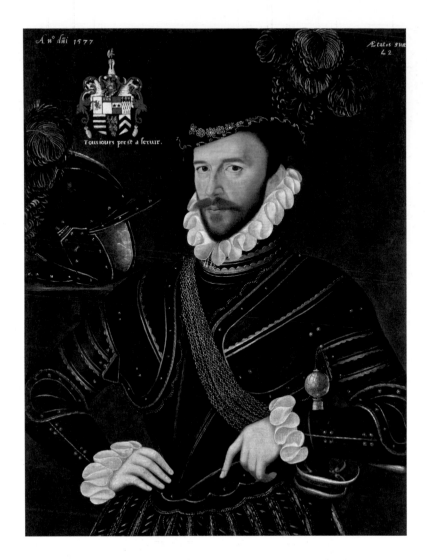

Following Elizabeth's death, Gheeraerts retained his leading position and was appointed painter to James I's queen, Anne of Denmark. In his case, the high quality of his work, and his comparatively distinctive style, do make it possible to establish a fairly substantial oeuvre for him.

In parallel to large-scale painting, from the mid 1520s onwards, tiny portrait miniatures were produced for elite clients in England, particularly those associated with the Court. These will be examined in detail in the next essay, which is about Nicholas Hilliard, the leading portrait miniaturist of the late sixteenth century. Miniature painting, or limning, developed out of the techniques used for manuscript illumination, especially in the Netherlands, but other practitioners in England, whose names are now largely lost, also painted in watercolour on

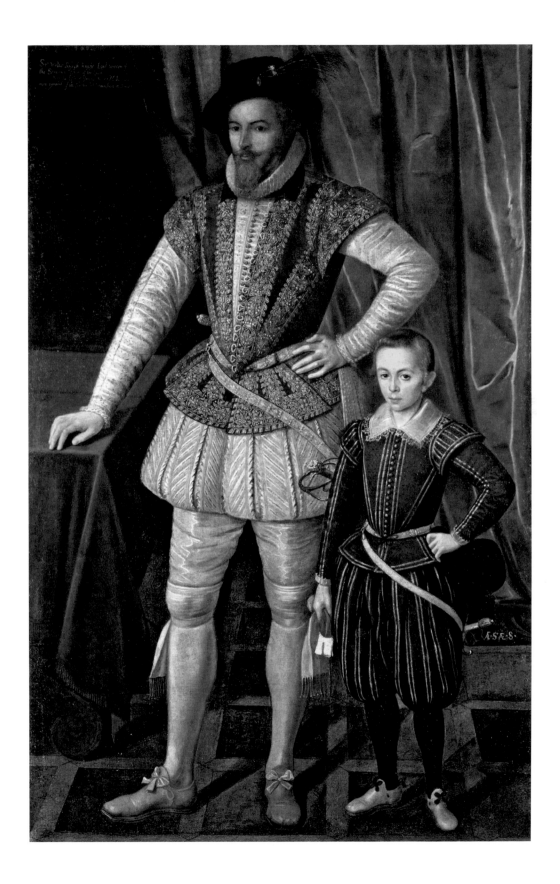

vellum or paper. Among these was John White (active 1585–93), a Cornish gentleman and artist who made some remarkable water-colours that documented aspects of indigenous peoples that he encountered in America.[4] Indeed, watercolour was frequently used in surveys, including those by John Norden, who was appointed surveyor of the Duchy of Cornwall in 1605 and who in 1617 produced a volume on the Duchy's property for the future King Charles I.

Most of the evidence that survives for painting and sculpture in what might be termed 'the long Elizabethan age' relates to work for clients at the very top of society, and particularly for the court elites in London. Nevertheless, it is clear not only that some West Country-born individuals were active commissioners of art (particularly of portraits), but also that a number of practitioners from the West Country played significant roles in its production.

NOTES

1 Susan Foister, *Holbein & England*, New Haven and London, 2004.

2 *Ibid*. Holbein also made portrait miniatures, similarly based upon his own drawings.

3 See the technical investigations carried out on paintings in the Tate collection, undertaken under the supervision of Rica Jones and Karen Hearn between 1998 and 2010, and the present 'Making Art in Tudor Britain' project at the National Portrait Gallery, London (2008 to present day).

4 See the various essays in Kim Sloan (ed.), *European Visions: American Voices*, London, 2009.

NICHOLAS HILLIARD

Karen Hearn

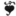

THE MOST SIGNIFICANT ARTIST TO EMERGE from the city of Exeter, the miniature-painter Nicholas Hilliard (fig. 17), was probably born in 1547, the year in which King Henry VIII died. Nicholas was the eldest child of the Exeter goldsmith Richard Hilliard and his wife Laurence, née Wall, whose father was also a goldsmith in the city.[1] Two years after the birth of his son, Richard and another wealthy Exeter merchant, John Bodley, who were both fervent Protestants, became involved in the siege of Exeter. When the Catholic Queen Mary I came to the throne in 1553, Bodley, in order to practise his religion freely, chose to go into exile on the Continent. His companions included his son Thomas, who would later establish the Bodleian Library at Oxford University, and young Nicholas Hilliard. The group are recorded in Germany in 1555 and in Calvinist Geneva in 1557, and these travels must have given Nicholas an unusually international experience and perhaps a knowledge of foreign languages.

On their return to England in 1559, after the accession of the Protestant Elizabeth I, Nicholas may have gone to live with John Bodley in London. In November 1562 he was apprenticed there to Robert Brandon, Elizabeth's goldsmith. His training would have familiarized him with precious metals and stones, and in how to make the ornate cases in which portrait-miniatures were sometimes set – such as the 'Drake Jewel' (fig. 14) – and it also equipped him to design medals. On 29 July 1569 Hilliard became a freeman of the London Goldsmiths Company, and accordingly, like his father back in Exeter, able to practise in his own right.

The European tradition of manuscript illumination had long included painted likenesses, but the portrait miniature as a discrete object, rather than on a manuscript page, is thought to have appeared in around 1524–25, at both the French and English courts. In France

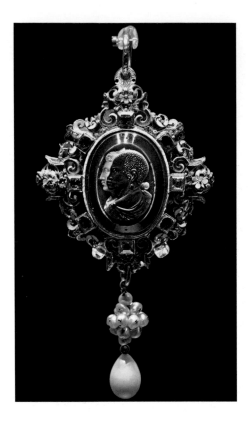

they were made by the Netherlandish court painter Jean Clouet
(1485/90–1541), while in England small images of Henry VIII and of
members of his family were probably produced by the Netherlander
manuscript-painter Lucas Horenbout (c. 1490/95–1544).[2]

The technique used by both Horenbout and Clouet was to apply
water-based pigments to a small section of very fine vellum which had
already been glued on to a piece of card, generally cut from a play-
ing card. Although it is unclear how or when he learned it, this is the
process that Hilliard followed. He first laid in a base for the face area
in flesh-toned colour (referred to as the 'carnation'), over which he
drew in the outlines and then painted in the features with transpar-
ent hatching strokes, using a very fine paint brush. Hilliard seems to
have worked directly on to the vellum, with the sitter in front of him
and, unlike Hans Holbein II (see previous essay), does not seem to have
made any intermediary drawing on paper first.[3]

Various now-unidentified manuscript illuminators were active in
mid-sixteenth-century London – those, for instance, who decorated the
numerous official documents made on behalf of Edward VI, Mary I
and, from 1558 onwards, Elizabeth I. They could have provided a link

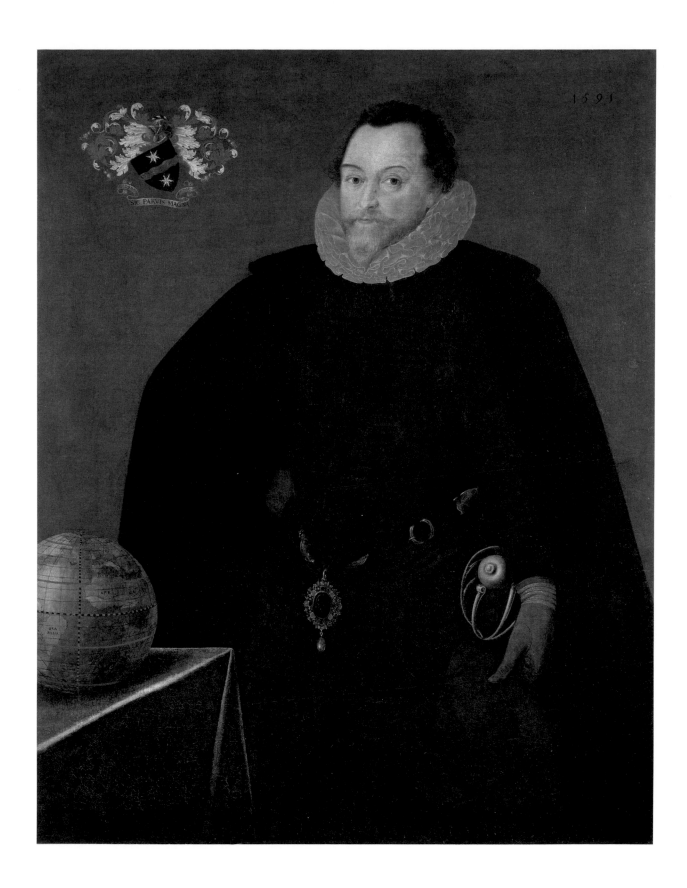

reaching back to the techniques used by Horenbout.[4] The sixteenth-century term for this was 'limning'. In around 1600, Hilliard wrote *A Treatise Concerning the Arte of Limning*, on the nature and status of miniature-painting, and describing some of the techniques that he employed.[5] He apparently produced it for the doctor and art enthusiast Richard Haydocke, who observed that Hilliard's work was "so much admired amongst strangers [that is, abroad]", and praised "his perfection in ingenuous Illuminating or Limming, the perfection of Painting".[6]

Hilliard's text is both a formal explanation of the theory and status of limning and a practical manual of some of Hilliard's own methods and materials of painting – although, unusually, it links these with precious stones (reflecting his training as a goldsmith). It also contains elements of personal biography. Hilliard reveals his meticulous working practices, emphasizing the importance of a particular painting environment and stressing that a limner should be clean in his person and highly self-disciplined. This seems to have been central to Hilliard's careful construction of the portrait-miniaturist as a gentleman.[7]

Portrait miniatures are fragile, and only a small proportion of Hilliard's total output can have survived. His limnings incorporate elements found also in the large-scale portraits of the period. Pieces of text are included with the image, the words contributing significantly to the message of the portrait, as, for example, in Hilliard's miniature of *Charles Blount, later Earl of Devonshire*, of 1587, which is inscribed in Latin: *Amor amoris premium* (Love is the reward of love). In sixteenth-century portraiture, details of costume were extremely important. Status and wealth are conveyed through the depiction of a sitter's jewellery, for instance, and of rich and decorated fabrics. Both Hilliard and the large-scale painters carefully recorded these.

In an era in which large-scale portraits presented a very public face, the miniature, in contrast, was generally small enough to be viewed while held in the hand, giving a personal, one-to-one experience. Few remain in their original cases. There are many early references to the 'portrait boxes' in which many were kept, and some still survive in early turned-ivory circular settings – such as Hans Holbein's miniature of Anne of Cleves and Hilliard's 1602 image of a well-heeled middle-class woman (both Victoria and Albert Museum, London). Miniatures were also set in pieces of jewellery, such as lockets and pendants, emphasizing their function as luxury items. Such a locket might be worn with the lid closed or occasionally open, so that the wearer could display the miniature and thus his or her personal or political allegiance. The

Rowland Lockey, *Charles Howard,*
2nd Baron Howard of Effingham and 1st
Earl of Nottingham, 1605, watercolour
on vellum © National Maritime
Museum, Greenwich, London

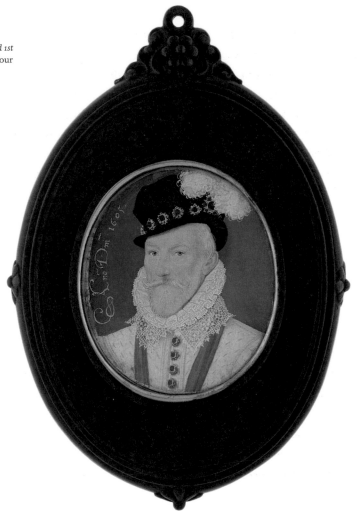

'Drake Jewel' miniature case that still survives today is depicted, worn closed, in the large-scale portrait of Hilliard's fellow West Countryman Sir Francis Drake, attributed to Marcus Gheeraerts II, of 1591 (see fig. 15).

Nicholas Hilliard subsequently took on apprentices of his own, under the aegis of the London Goldsmiths Company. We know the names of some of them, but not whether they were to be active as goldsmiths or as limners, although Rowland Lockey (*c.* 1565–1616), who was apprenticed to him in 1581, his son Laurence Hilliard (1582–1647/48), apprenticed to him in *c.* 1597, and the French-born Isaac Oliver (*c.*1560/65–1617) did subsequently practise as miniaturists. A limning of the commander of the English campaign against the Spanish Armada, Charles Howard, 2nd Baron Howard of Effingham, as an older man, painted in a style that echoes that of Nicholas, has been attributed to Lockey (and formerly to Laurence; cat. 16)

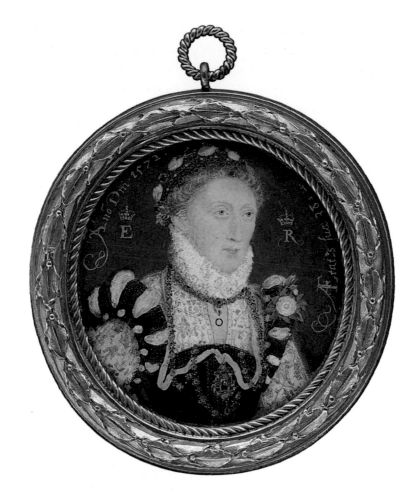

What may be Hilliard's earliest surviving miniature is dated 1560 and
depicts, posthumously, the Protestant Edward Seymour, Lord Protector
Somerset.[8] The earliest definitely identified limning by Hilliard is dated
1571 and is of an unknown man (private collection).[9]

In 1572 Elizabeth I seems to have sat for the first time to Hilliard. In
his treatise, he described their conversation "when first I came in her
highness presence to drawe". The queen apparently first discussed the
use of shadow in painting, and stated that "best to showe ones selfe,
nedeth no shadow of place but rather the open light". Hilliard says he
replied that, although dark lines might make a large painting read well
at a distance, miniature-painting did not require them because it was
meant to be viewed "of nesesity in [the] hand neare vnto the eye". He
adds that the queen immediately saw his point "and therfor chosse her
place to sit in for that porposse in the open ally of a goodly garden,
where no tree was neere, nor anye shadowe at all".[10]

Hilliard's earliest miniature of the queen may be the one in the National Portrait Gallery. He was to depict her many times – at least fifteen miniatures of her by him survive, each one different (see fig. 16). Sir John Harington, of Kelston – another West Countryman – later described how he had seen Hilliard "in white and blacke in four lynes only, set downe the feature of the Queenes Majesties countenance ... and he is so perfect therein ... that he can set it down by the Idea he hath, without any patterne".[11]

In July 1576, in London, Hilliard married Alice Brandon, daughter of his former master (fig. 18). Soon after, the couple travelled to France, where Hilliard entered the household of Elizabeth I's French suitor, François, duc d'Alençon. As "Nicholas Heliart (*compagnon anglais*)" he appears in the Paris goldsmiths' records, implying that he set up a workshop there. While in France, Hilliard painted his own self-portrait, in which he depicts himself not as a painter but as a gentleman, indistinguishable from his elite clients (fig. 17).

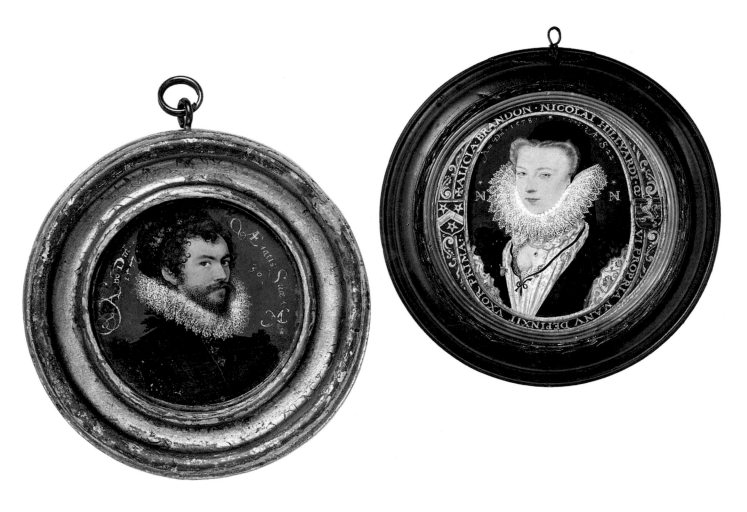

Back in London in *c.* 1578–79, he and Alice, with their first child, moved into a house in Gutter Lane, off the Strand, which he leased from the Goldsmiths Company. For the next 35 years, this property, called 'The Maydenhead', must have been where Hilliard both lived and had his studio.

It is not clear whether Hilliard held a formal court post in England, but a surviving draft document, dated 1584, but apparently never enacted, would have given the painter of large-scale images George Gower (see previous essay) a monopoly for painting all portraits of Elizabeth I, with the exception that Hilliard would be allowed to "make purtraicts, pictures, or proporcons of our body and person in small compasse in lymnynge only, and not otherwise".[12]

Reflecting his training as a goldsmith, Hilliard also collaborated with Dericke Anthony, the 'Graver to the Mint', between 1584 and 1586, to make Elizabeth I's second Great Seal. The 1580s and early 1590s were probably Hilliard's most successful years, during which he portrayed many of the leading figures at court – including Sir Francis Drake

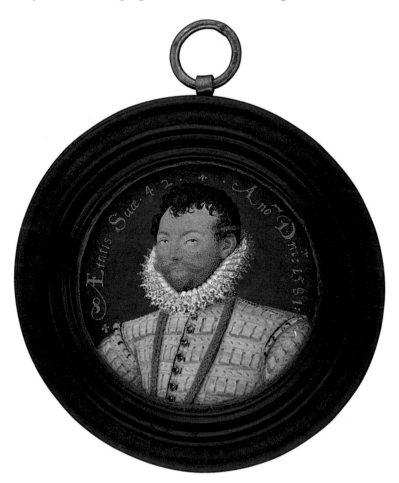

FIG. 19
Nicholas Hilliard, *Sir Francis Drake*, 1581, watercolour on vellum © National Portrait Gallery, London

Nicholas Hilliard, *Leonard Darr*,
1591, watercolour on vellum,
Private collection

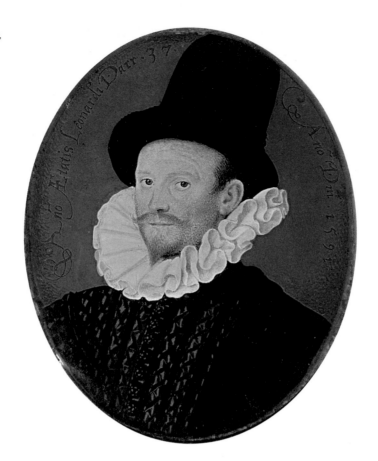

(fig. 19) and Sir Walter Ralegh, as well as Elizabeth herself, from whom he would receive a gift of £400 in 1591. He was also employed by middle-class sitters, such as the wealthy merchant from Tavistock Leonard Darr in 1591 (cat. 17). Hilliard's usual payment for an unframed miniature seems to have been about £3.[13]

Although most of Hilliard's limnings are head-and-shoulders images, finished off initially in the traditional circular format and then, after his return from France, in a new oval shape, he sometimes produced small full-lengths, such as the finely detailed, rectangular portrait of the aristocratic privateer George Clifford, 3rd Earl of Northumberland, shown in his costume for an Accession Day tilt, performed before the queen.

It seems that Hilliard may also have painted full-scale pictures. In 1600 he undertook "to make and bestowe on the [Goldsmiths] Companie a faire picture in greate of her Ma^tie". Of course, working on wooden panel or on canvas required wholly different techniques.

After Elizabeth's death in March 1603, her successor, James VI of Scotland, now James I of England, chose Hilliard as his limner (cat. 18). James would continue to employ him both as a miniature

Nicholas Hilliard and studio, *James I*,
c. 1610, watercolour on vellum
© Victoria and Albert Museum,
London

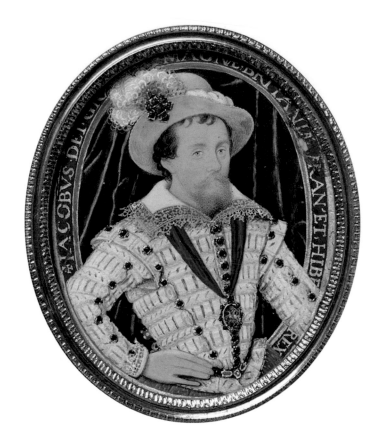

painter and a medal-maker, although his work was probably no longer seen as cutting-edge. Hilliard was required to make numerous miniatures of James and members of his family, and seems to have called on, and increasingly relied on, his various assistants to help with this.[14]

In 1613 he turned the Gutter Lane workshop over to his son Laurence and moved to Westminster. Four years later, Nicholas was granted a twelve-year monopoly to engrave and print portraits of the royal family, but was also then briefly imprisoned for debt. (References to financial problems recur throughout Hilliard's life – including in his own treatise.) The monopoly described him as James I's "wel-beloved Servant Nicholas Hilliard, gentleman, our principal Drawer for the small Purtraits and Imbosser of our Medallions of Gold".[15] Hilliard made his will on Christmas Eve 1618,[16] and was buried at St Martin-in-the-Fields on 7 January 1619.

Although Hillliard's career was London-based and court-orientated, individuals of West Country origin were always among his clients. A shared geographical background may have played some part in their decision to sit to him – the leading miniature-painter of his time.

NOTES

1 H.C.G. Matthew and Brian Harrison (eds.), *Oxford Dictionary of National Biography*, XXVII, Oxford: Oxford University Press, 2004 (entry on Nicholas Hilliard by Mary Edmond, pp. 217–24).

2 Katherine Coombs, *The Portrait Miniature in England*, London: V&A Publications, 1998.

3 Edward Norgate, *Miniatura or the Art of Limning*, ed. Jeffrey M. Muller and Jim Murrell, New Haven and London: Yale University Press, 1997.

4 Karen Hearn, *Nicholas Hilliard*, London: Unicorn Press, 2005, pp. 10–11.

5 Nicholas Hilliard, 'A Treatise Concerning the Arte of Limning', MS Laing III, 174, Edinburgh University, ed. R.K.R Thornton and T.G.S. Cain, as *The Arte of Limning*, Ashington and Manchester: Carcanet Press/Mid Northumberland Arts Group, 1981; all quotations from Hilliard's treatise in this essay are taken from this edition. The manuscript is not written in Hilliard's own hand but probably by a professional scribe, and is dated 1624 – that is, five years after Hilliard's death. It seems to be a draft rather than a finalized account; its opening appears to be missing and it breaks off before its intended conclusion.

6 Erna Auerbach, *Nicholas Hilliard*, London: Routledge & Kegan Paul, 1961, p. 46.

7 Katherine Coombs, '"A Kind of Gentle Painting": Limning in 16th-Century England', in Kim Sloan (ed.), *European Visions: American Voices*, London: British Museum, 2009, pp. 77–84.

8 Reproduced in Hearn, *Nicholas Hilliard*, as no. 1, pp. 28–29.

9 Reproduced in Auerbach, *Nicholas Hilliard*, as pl. 16, p. 60.

10 Hilliard, ed. Thornton and Cain, p. 87.

11 *Ibid.*, p. 112, note 47.

12 *Ibid.*, p. 20.

13 For the sum he received in 1585/86 for an image of the Earl of Northumberland, and again in 1592 for "the drawing of one picture" for Bess of Hardwick, the Countess of Shrewsbury, see Auerbach, *Nicholas Hilliard*, p. 24.

14 Graham Reynolds, 'Portraits by Nicholas Hilliard and his Assistants of King James I and his Family', Walpole Society, vol. XXXIV, 1952–54, pp. 14–26.

15 Auerbach, *Nicholas Hilliard*, p. 40.

16 The National Archives, Prob. 11/133/2.

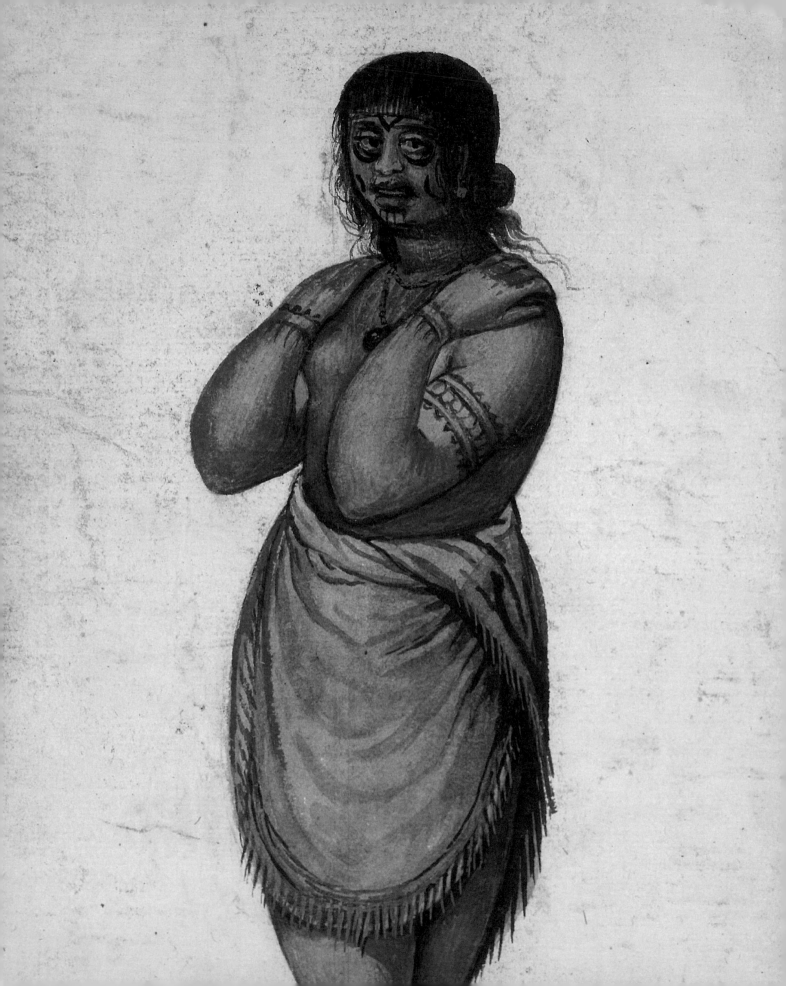

MARITIME ACTIVITY & EXPLORATION

Stephanie Pratt

WEST COUNTRY COMMANDERS ARE remembered for their preying on Spanish treasure fleets,[1] their participation in the defeat of the Armada, their involvement in exploration and in the early settlements in America. Nothing shows more clearly the contribution made by Devon and Cornwall to the international reach of Elizabeth's realm.

Sir John Hawkins operated as a trader and privateer in the 1550s, based in Plymouth (fig. 21). He is more notorious, however, as the figure who initiated English involvement in the slave trade.[2] Supported by a syndicate of London merchants, his first slaving voyage took place in 1562–63, buying or seizing Africans in Sierra Leone and selling them to Spanish plantation owners in the Caribbean. Hawkins's second voyage to the West Indies (1564–65) was backed by the queen herself, who loaned him one of her ships, the 700-ton *Jesus of Lubeck*. His third and final voyage (1567–69), accompanied by Drake, ended in near-disaster when Hawkins, having sold his slaves, encountered a strong Spanish force at San Juan de Ulùa on the Mexican coast. Drake abandoned him and Hawkins returned to Plymouth with a handful of survivors. In the 1570s Hawkins was active in counter-espionage and commanded a flotilla of ships based at Plymouth. He was made Treasurer of the Navy in 1577 and in that office helped persuade the Admiralty to accept new warship designs – for faster, low-built ships with increased armaments – which proved their effectiveness against the Armada in 1588.

Born near Dartmouth, John Davis was a neighbour of Ralegh and the Gilbert family.[3] Sir Humphrey Gilbert (fig. 22) had argued before Elizabeth in 1566 for the existence of a northern route to Cathay (China). Davis and Adrian Gilbert were visited at their homes in Devon by Dr John Dee and in early 1583 discussed the North-West Passage with Sir Francis Walsingham. Davis led three Arctic voyages in pursuit of this goal (1585, 1586 and 1587) and investigated the Canadian coast, reaching 72°92′ N, a higher latitude than any mariner before him. His

FIG. 20
John White, *Young woman of Aquascogoc* (detail of cat. 21)

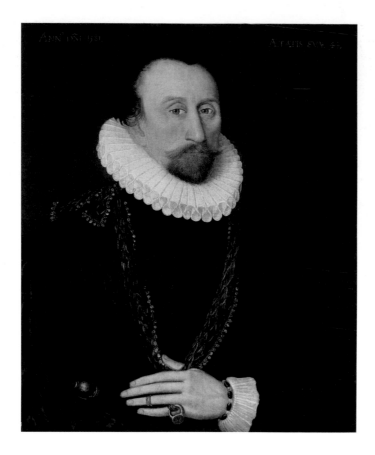

contribution to navigation was considerable, in publishing two impor-
tant treatises, *The Seaman's Secrets* (1594) and *The Worldes Hydrographical
Discription* (1595), and in inventing the Davis backstaff, which enabled
sailors to measure the height of the sun more accurately. He made
three voyages to the Far East between 1598 and 1605, in a subordinate
role, and was killed by Japanese pirates in December 1605.

The Bristol merchant John Cabot's voyage to Newfoundland in 1497
helped form the basis of England's claims to the New World, but it
was the subsequent secret missions to the newly discovered lands by
Elizabeth I's West Country navigators and seamen that truly opened
up the possibility for English settlement in North America. When
Drake was circumnavigating the world he made landfall in northern
California on 17 June 1579, claiming the land for the English Crown and
naming it Nova Albion, meaning 'New Britain', but no attempt was
made to settle colonists there.[4] Instead, it was the Atlantic seaboard
which attracted interest, in an area of the coastline then claimed by
the English but still officially under Spanish jurisdiction. Sir Humphrey

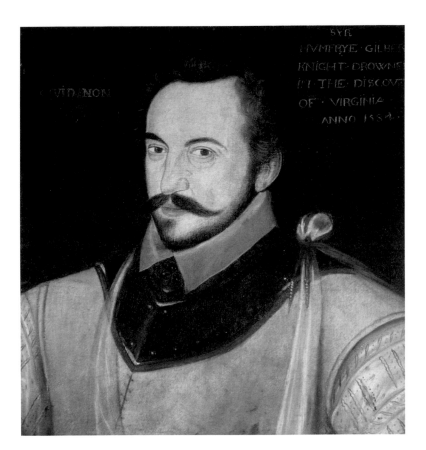

FIG. 22
Unknown artist, *Sir Humphrey
Gilbert*, oil on panel, *c.*1584
© Compton Castle, Torquay,
Devon / National Trust
Photographic Library /
The Bridgeman Art Library

Gilbert (fig. 22) had been granted a patent in 1578 to establish a colony in the New World. The first potential site he investigated was St John's, Newfoundland, where he landed in August 1583, claiming the harbour and 200 leagues' radius of territory in the Queen's name. Although St John's had had seasonal occupation by the Newfoundland fishing fleet from about 1520, Gilbert's was the first official claim. Returning to England he was drowned when his ship, the *Squirrel,* was lost in a storm.

Gilbert's half-brother Sir Walter Ralegh took over the patent and was to become the most important of the Devon promoters of exploration and settlement. His 'Virginia' plantation project, named in honour of the Virgin Queen Elizabeth I, began with a fact-finding voyage in 1584, led by captains Arthur Barlowe and Philip Amadas. They landed on Roanoke island in the Outer Banks, near Pamlico Sound in present-day North Carolina. Barlowe's letter to Ralegh described the Secotan and Croatan Indian inhabitants as "gentle, loving and faithful, void of all guile and treason, and such as live after the manner of

the golden age".[5] This favourable report encouraged Ralegh to estab-
lish a settlement at Roanoke, and a fleet left Plymouth on 9 April 1585,
under the command of Sir Richard Grenville (cat. 19). On 17 August
107 men were disembarked to establish the colony and Grenville left
for more men and supplies, hoping to return in April. Relations with
the Indians deteriorated, however, and in June 1586 the colonists took
passage with Drake, who was returning home from successful raiding
in the Caribbean. Grenville's relief fleet arrived soon afterwards to find
the colony deserted but they left a small contingent behind to protect
Ralegh's claim.

The 1585 Roanoke contingent had included John White, the expedi-
tion's artist/cartographer, and Thomas Harriot, the science officer or
naturalist, who had previously taught Ralegh navigation. Harriot took
extensive notes, which formed the basis for his published account of
the voyage, *A Briefe and True Report of the New found land of Virginia*
(1588). John White was a gentleman, probably born in Cornwall, and
was a very capable artist. It is likely that he is the John White listed as a
member of the Painter-Stainers Company in 1580.[6] He produced over
seventy watercolour drawings of the flora and fauna and the Indian
inhabitants of the area, twenty of which concentrate solely on their
daily life and customs. White's drawings are justly celebrated for being
some of the very first to depict indigenous peoples from the life and he
benefitted from having Indian interpreters in his retinue to help him
understand what he was recording.[7]

White's drawings, and the set of related watercolours based on
his originals in the 'Sloane Manuscript'[8], reveal what aspects of indi-
genous Algonquian culture were of interest to the expeditionary team
and those backing them. Many of the village and group scenes show
a settled agricultural society whose members sustain themselves by
hunting, fishing and farming. The drawing of the village of Pomeiocc
from the Sloane Manuscript shows a well-organized community with
a central ceremonial fire and encircled by a protecting wall of timber
(cat. 20). Another watercolour shows the village of Secoton depicted as
an orderly self-sufficient society, the houses lined along a central path
(fig. 24). The single-figure drawings of local Algonquians, for example
Young woman of Aquascogoc (cat. 21), *The Wife of an Herowan of Secoton*
(cat. 22) and *Noble man with bow* (fig. 23) were probably developed to
illustrate Harriot's *Briefe and True Report* of 1588.[9]

Ralegh sent a third fleet to America in 1587, carrying 150 colonists
intended to settle in Chesapeake Bay, with White as their Governor.

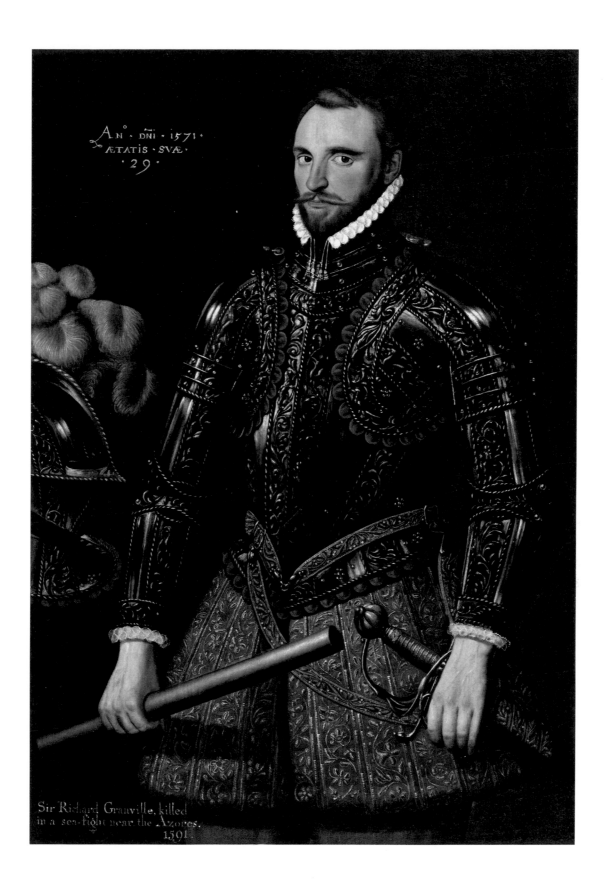

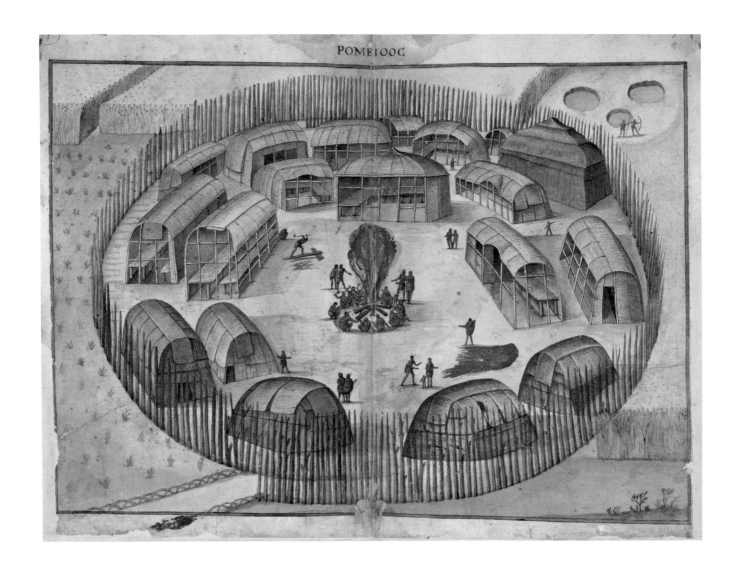

POMEIOOC

Initially, however, they were instructed to land at Roanoke to take off the men Grenville had left there the previous year. There was no sign of them and, for reasons that remain unclear, the colonists were refused permission to re-embark. Ralegh's colony was therefore established on Roanoke again. Relations with the Indians remained poor and White returned to England in late 1587 to seek assistance, leaving behind his new grand-daughter Virginia Dare and some 113 settlers. The Armada threat frustrated his attempts to return in 1588, and he did not reach Roanoke again until August 1590. The site was deserted and the fate of the colonists remains unknown.

Although Roanoke failed as a venture and lost Ralegh a great deal of money, the drive to found an English colony in America was not

20

John White, *The village of Pomeiooc*, 1585–93, watercolour with pen and ink © The Trustees of the British Museum

extinguished.[10] James I issued charters in 1606 to two joint-stock companies, attracting private investment to fund settlements in Virginia. These were the Virginia Company of Plymouth and the Virginia Company of London, each allocated a section of coast to colonize.[11] The Virginia Company of Plymouth founded a short-lived colony at Sagadahoc in present-day Maine, also called the Popham Colony after its first leader George Popham. Popham, and his second-in-command Ralegh Gilbert, the son of Humphrey Gilbert, sailed from Plymouth aboard the *Gift of God* on 31 May 1607.[12] For a variety of reasons (but not owing to hostility from indigenous peoples), the colony failed after a year. As is well known, Jamestown in Virginia, the colonial settlement established in 1607 by the London Company, nearly failed during its first winter. Important figures such as John Smith, who led the colony for a time and helped to negotiate with the local indigenous peoples, and Pocahontas, the young Powhatan woman who eventually married

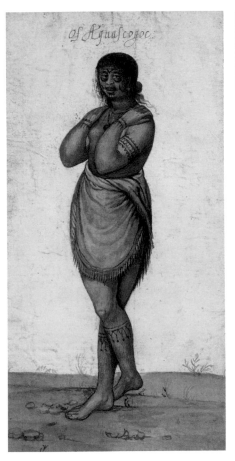

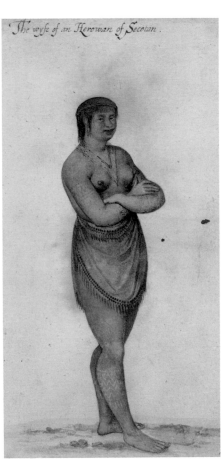

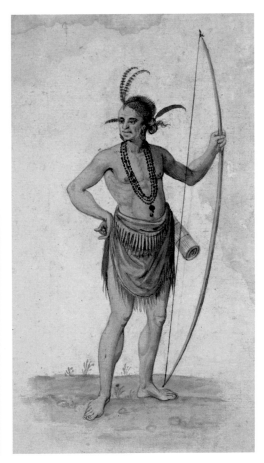

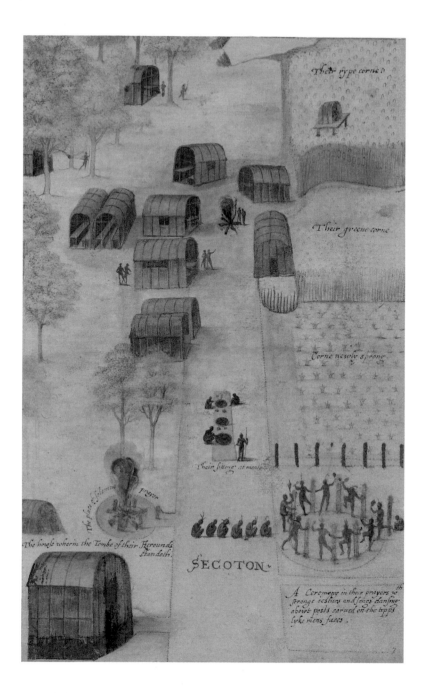

one of the Jamestown colonists, John Rolfe, helped to maintain peaceful relations and thus support this colony through its most threatened period. Twenty-five years after Humphrey Gilbert's pioneering venture, the first permanent English colony had been established in America.

NOTES

1 Much of this activity was simple piracy, to which the government turned a blind eye. When hostilities broke out ships could sail as privateers, issued with 'letters of marque' which enabled them to plunder any enemy ships they encountered.

2 For Devon's involvement with Africa in the sixteenth century, see Todd Gray, *Devon and the Slave Trade*, Exeter: Mint Press, 2007, pp. 17–30. The earliest Devon ventures into what would become the Atlantic trading nexus were undertaken by William Hawkins, Sir John's father, who was a distinguished Plymouth seaman during Henry VIII's reign, making three voyages to Brazil from 1530 to 1532. The elder Hawkins's Atlantic activities were published in Richard Hakluyt's *The Principall Navigations, Voyages, Traffiques and Discoveries of the English Nation*, 2nd edn, 1598–1600, X.

3 The place and date of Davis's birth have been recently clarified in Ray Freedman and Eric Preston, *John Davis 1543–1605: The Master Navigator from the Dart*, Dartmouth History Research Group paper 33, 2007.

4 The *Golden Hind*'s company was reduced in number when Drake arrived at the Moluccas in November. This has led some to suppose that he left men behind to colonize Nova Albion, but modern scholars are unconvinced.

5 Quoted from Arthur Barlowe's letter to Ralegh entitled *The First Voyage to Roanoke. 1584. The First Voyage Made to the Coasts of America, with Two Barks, wherein Were Captains M. Philip Amadas and M. Arthur Barlowe, Who Discovered Part of the Countrey Now Called Virginia, anno 1584. Written by One of the Said Captaines, and Sent to Sir Walter Ralegh, Knight, at Whose Charge and Direction, the Said Voyage Was Set Forth*. See http://docsouth.unc.edu/nc/barlowe/barlowe.html.

6 See Kim Sloan, *A New World: England's First View of America*, London: British Museum, 2007, and Kim Sloan (ed.), *European Visions: American Voices*, London: British Museum, 2009.

7 Paul Hulton and David Beers Quinn, *The American Drawings of John White, 1577–1590; with Drawings of European and Oriental Subjects* (reproductions of the originals in colour facsimile and of derivatives in monochrome), 2 vols., London: The Trustees of the British Museum, 1964. See also Michael Leroy Oberg, 'Between "Savage Man" and "Most Faithful Englishman": Manteo and the Early Anglo-Indian Exchange, 1584–1590', *Itinerario, European Journal of Overseas History*, Leiden University, The Netherlands, XXIV/2, 2000, pp. 146–69.

8 See the discussion of the Sloane Manuscript in Kim Sloan, *A New World*, pp. 224–25.

9 For more information on the various volumes making up de Bry's *Grand Voyages* see the Library of Congress website at http://international.loc.gov/service/rbc/rbdk/d031/inanalytics_america.html.

10 In 1602 Bartholomew Gosnold landed on Cuttyhunk Island, one of the Elizabeth Islands in Massachusetts, and built a small fort there, but after a month he returned to Falmouth.

11 The London Company had rights to the coast between 34° and 41° N; the Plymouth Company between 38° to 45° N. The area between 38° and 41° would become the property of whichever became the stronger colony.

12 Archaeologists rediscovered the Popham colony site in 1994. For a popular account, see Myron Beckenstein, 'Maine's Lost Colony,' *Smithsonian Magazine*, February 2004, available online at http://www.smithsonianmag.com/.

C.

D

D

D

D

D

E

F

E

D

G

To this place the
Castle Lands con
by an vnknow
boundes from
other hands.

The high Streete of the Citie of Eaon.

EDUCATION
& LEARNING

Sam Smiles

B Y THE EARLY SIXTEENTH CENTURY, IN addition to smaller schools there were grammar schools in Devon and Cornwall at Exeter, Ottery St Mary, Crediton, Ashburton, Barnstaple, Week St Mary, Launceston, Saltash, Bodmin and Penryn. The Reformation wrested control of education from the Church, but most schools like these were maintained after the reforms.[1] In addition, several new schools were established in the wake of the Chantry Acts of the 1540s, when many towns petitioned the Crown to use the assets of dissolved monastic possessions for educational purposes. The Edward VI Grammar School in Totnes is one such example, inaugurated in 1553 in the buildings of the former Totnes Priory. John Davis, the navigator, probably studied there.[2] These schools served the children of the middle ranks of society, offering education to boys, primarily the study of Latin, religion and arithmetic. Those intending a professional career went on to the universities of Oxford and Cambridge and/or the Inns of Court. Aristocratic children more typically received their early schooling from private tutors.

Little is known about the schoolmasters of these establishments but some of the exercises used by John Conybeare, who taught at South Molton and then at Swimbridge in the 1580s and 1590s, have survived.[3] More advanced tuition in this period was offered by the master at Plymouth, William Kempe, who had trained at Cambridge and was a follower of the educational reformer Peter Ramus (1515–1572).[4] Kempe published two pedagogical tracts: *The Education of Children in Learning* (1588; dedicated to William Hawkins, Mayor of Plymouth) and his translation of a work by Ramus, *The Art of Arithmeticke in Whole Numbers and Fractions* (1592; dedicated to Sir Francis Drake).

The biggest grammar school in the region was a new institution, established in Tiverton at the turn of the century by the wealthy cloth merchant Peter Blundell, who bequeathed a very large sum of money

FIG. 25
John Norden, *Plan of Exeter castle* (detail of cat. 26)

FIG. 26
Blundell's School, Tiverton,
Devon © Blundell's School,
Tiverton

to found a new school that would teach 150 pupils, aged six to eighteen (fig. 26). The instructions in his extensive and detailed will were faithfully followed, the school building being 100 feet long by 24 feet wide, with glazed windows, settles and forms for seating, an oak-planked floor and a four-foot partition in the middle to divide the Upper from the Lower school. Blundell was a Puritan and established scholarships for his pupils at Oxford (Balliol) and Cambridge (Sidney Sussex) "for the increase of good and godly preachers of the gospel".[5]

Born at Greenway, near Dartmouth, Sir Humphrey Gilbert is best known for his exploits as an explorer and soldier, but he also had aspirations to reform education. Gilbert believed that the quality of the Elizabethan Court would be improved if an academy were established in London where wards and the sons of gentlemen, together with courtiers and students at the Inns of Court, would study not only standard texts but also practical subjects – modern languages, history, civil law, politics, arithmetic, natural philosophy, martial arts, military strategy, medicine, cosmography, navigation and music. A copy of every book, proclamation or pamphlet printed in England should, he thought, be deposited in the Academy's library and its lecturers should publish new scholarly works or translations regularly. The proposal, which dates from 1570, required large capital and running costs that were over-ambitious, but Gilbert's promotion of a new curriculum was

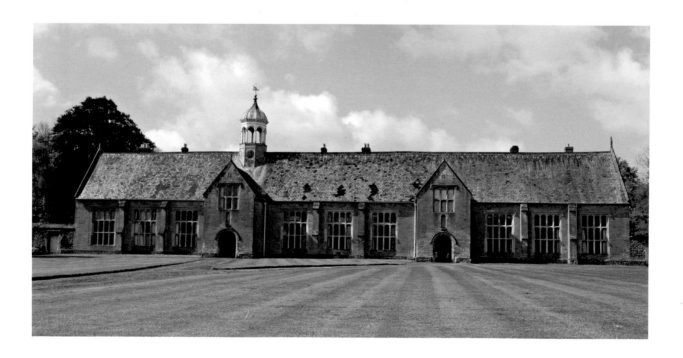

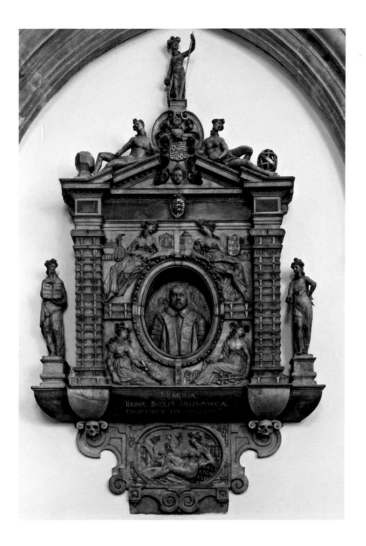

FIG. 27
Nicholas Stone, *Bodley Monument, Merton College, Oxford, c. 1615* © The Warden and Fellows of Merton College, Oxford. Photography by Colin Dunn (Scriptura Ltd)

pioneering and is of a piece with his commitment to the new humanist learning of the later sixteenth century.[6]

Sir Thomas Bodley's support for education took a more practical route. Born in Exeter to a Protestant family, during Mary I's reign he was brought up in exile in Geneva, along with Nicholas Hilliard, who had been placed with the family by his father. Returning to London after Mary's death, Bodley was educated at Oxford and subsequently taught there. From the later 1570s he was also active in foreign diplomacy, but in the last fifteen years of his life he worked to restore the former university library at Oxford at his own expense. It grew rapidly after its opening in November 1602 and soon needed to be extended, again funded by Bodley, who left the majority of his personal fortune to the library in his will.[7]

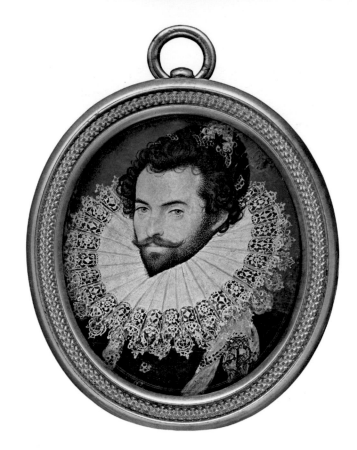

23

Nicholas Hilliard, *Sir Walter Ralegh,*
c. 1585, watercolour, bodycolour and
silver on vellum © National Portrait
Gallery, London

24

Unknown artist, *John Hooker,*
c. 1601, oil on panel © Royal Albert
Memorial Museum *&* Art Gallery,
Exeter City Council

As Bodley's project came to fruition, his contemporary Sir Walter
Ralegh (cat. 24) languished in the Tower of London, where he was
imprisoned in 1603. Already a prose writer of distinction and a poet
of considerable refinement, Ralegh began in about 1607 to write *The*
History of the World, the first part of which was printed in 1614. Divided
into five books, the narration begins with the Creation and ends in the
second century BC, thus incorporating biblical and classical history and
offering examples for modern rulers to follow. Initially suppressed for
its verdicts on the wickedness of monarchs, the book was reprinted
in 1617 and went through another eleven editions in the seventeenth
century.

Ralegh's book was concerned with incidents of epochal importance
and his approach to his material was as much philosophical as it was
historical, but the past could also be approached by a detailed scrutiny
of what lay close to hand. The contribution to learning made by anti-
quarian writers from Devon and Cornwall in this period was consid-
erable, benefiting both the region and the nation and initiating deve-
lopments which proved influential long after the Elizabethan era had
ended. The first of these antiquarian scholars of the South West was
John Hooker (cat. 25), who was born in Exeter, educated in Oxford,

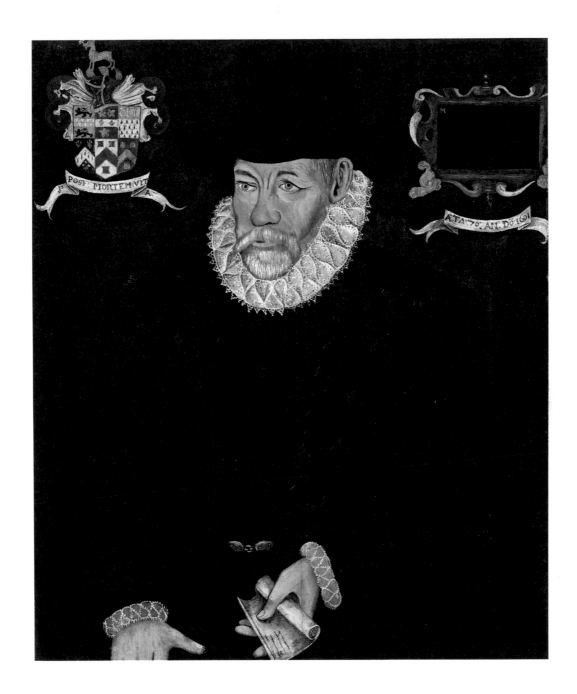

Cologne and Strasbourg, and in 1555 became the first chamberlain of his native city. This gave him access to its ancient records, which he ordered and catalogued. He represented Exeter in Parliament in 1571 and 1586 and published *The Order and Usage how to Keepe a Parlement in England* (1572), which, with other contributions by him, was incorporated in the second edition of Raphael Holinshed's *Chronicles* (1587). Hooker was a member of the short-lived Elizabethan Society of Antiquaries and in

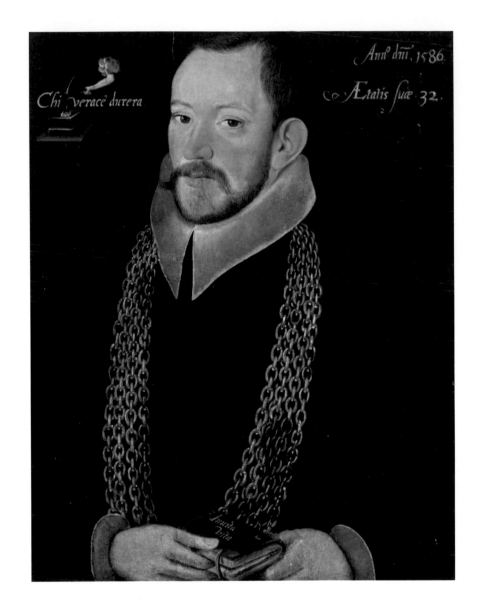

In the painting:
Ann° dñi. 1586
Æ.tatis suæ. 32.
Chi verace durera

the 1590s wrote a number of important and foundational studies of the history of Exeter and the topography of Devon.[8]

His younger contemporary and friend Richard Carew (cat. 26) was born at Antony House, Torpoint. As an important landowner he performed various civic and parliamentary duties for Cornwall but, like Hooker, his major claim to fame was his intellectual work. He translated Italian and French authors, including a version of Torquato Tasso's *Gerusalemme liberata* (1594), and was widely respected as a scholar and linguist. Carew was also a member of the Society of Antiquaries and a close friend of William Camden, who relied on him for information

on Cornwall when preparing his *Britannia* (1586), the ground-breaking account of the history and geography of Britain. Carew's researches were published separately as the *Survey of Cornwall* (1602), dedicated to Sir Walter Ralegh.

The third major contributor to regional research was the surveyor and map-maker John Norden (see cat. 26). Born in Somerset, but living most of his adult life in London, in 1583 he conceived the idea of publishing a survey of all the English counties, to be called *Speculum Britanniae*, although only the volumes on Middlesex (1593) and Hertfordshire (1598) were published in his lifetime. His account of Cornwall, his most detailed, was completed by 1604. Reliant on Carew,

26

John Norden, *Plan of Exeter Castle* from *Survey of Prince Charles Manors Etc.*, 1617, bound volume © The British Library, Add. MS 6027, fols. 80–81

it nevertheless included new observations, for example discussing and illustrating Trevethy Quoit, where his training as a surveyor gave his visual records an accuracy and authority that improved on his predecessors' standards. He was granted the surveyorship of the Duchy of Cornwall in 1605 and produced accounts of its possessions, including lands belonging to it in Devon and elsewhere, in the 1610s.[9]

In their wake followed other topographical and antiquarian scholars, all born in Devon – Sir John Doddridge, Sir William Pole, Thomas Westcote and Tristram Risdon, whose work built on these foundations. Although much of their work remained in manuscript, it provided a store of information for later scholars. It is impossible to overemphasize the significance of these researches. The later sixteenth century witnessed an extraordinary flowering of antiquarian scholarship in England, which was intended to reveal something of the true history of the country for the first time. Scholarly research on the history and geography of the South West thus contributed to the national picture, as well as informing those readers who lived in Devon and Cornwall.[10]

NOTES

1 For example, Ottery's school was immediately re-founded, Crediton's resumed in 1547 after two years interruption. Ashburton's, however, was not re-established until 1593. For the state of education in the early 1500s, see Nicholas Orme, *Education in the West of England, 1066–1548*, Exeter: University of Exeter Press, 1976.

2 An earlier grammar school had been established in the town from about 1509 by the vicar William Gyles. See Thomas Kelly, *The History of King Edward VI Grammar School, Totnes*, Totnes: King Edward VI Grammar School, 1947.

3 Frederick Cornwallis Conybeare (ed.), *Letters and Exercises of the Elizabethan Schoolmaster John Conybeare*, London: Henry Frowde, 1905.

4 The grammar school at Plymouth was established in 1561, with the appointment of Thomas Brooke.

5 The first scholars at Sidney Sussex arrived in 1610, and at Balliol in 1615. See Charles Noon, *The Book of Blundell's*, Tiverton: Halsgrove, 2002.

6 [Sir Humphrey Gilbert], 'The erection of an achademy in London for educacion of her Majesties wards', in F.J. Furnivall (ed.), *Queene Elizabethes Achademy, A Booke of Precedence &c.*, London: Early English Text Society, 1869, pp. 1–12. See also Joan Simon, *Education and Society in Tudor England*, Cambridge: Cambridge University Press, 1966, pp. 341–43.

7 See Ian Philip, *The Bodleian Library in the Seventeenth and Eighteenth Centuries*, Oxford: Clarendon Press, 1983.

8 Iohn Vowell alias Hoker, *A catalog of the bishops of Excester: with the description of the antiquitie and first foundation of the Cathedrall church of the same*, London: Henrie Denham, 1584; *The antique description and account of the city of Exeter in three parts*, Exeter: Andrew Brice, 1765; William J. Blake, 'Hooker's Synopsis Chorographical of Devonshire', *Transactions of the Devonshire Association*, 47, 1915, pp. 334–48.

9 See Frank Kitchen 'John Norden (*c.* 1547–1625): Estate Surveyor, Topographer, County Mapmaker and Devotional Writer', *Imago Mundi*, 49, 1997, pp. 43–61.

10 For general accounts of this scholarship see Stan A.E. Mendyk, *'Speculum Britanniae': Regional Study, Antiquarianism, and Science in Britain to 1700*, London and Toronto: University of Toronto Press, 1989; Jan Broadway, *"No Historie So Meete": Gentry Culture and the Development of Local History in Elizabethan and Early Stuart England*, Manchester: Manchester University Press, 2006; Mark Brayshay (ed.), *Topographical Writers in South-West England*, Exeter: University of Exeter Press, 1996.

WHO'S WHO

INDIVIDUALS ASSOCIATED WITH DEVON & CORNWALL MENTIONED IN THE CATALOGUE

PHILIP AMADAS (*c.* 1565–after 1586)

Born in Plymouth, he became a member of Ralegh's household and in 1584 (aged nineteen) explored the coast of America in the *Bark Ralegh*. In 1585, as Admiral of Virginia and second-in-command to Richard Grenville, he settled colonists at Roanoke. He returned to England with Drake in June 1586 but no records of him exist after that date.

SIR JOHN ARUNDELL (d. 1580)

Wealthy Cornish landowner, he was MP for Mitchell, 1555 and 1558, and Sheriff of Cornwall in 1573–74, but not active in national politics; he concentrated instead on rebuilding Trerice House. His daughter Juliana married Richard Carew.

NICHOLAS BALL (d. 1586)

Influential Totnes pilchard merchant and trader, who was MP for Totnes, 1584, and Mayor, 1585–86. His fine townhouse still stands in Totnes High Street. His widow married Thomas Bodley.

SIR ROGER BLUETT (*c.* 1503–1566)

Committed Protestant, recorded as destroying crosses and seizing ritual objects from unreformed churches. Commanded Exeter's militia during the Prayer Book rebellion and received the thanks of Parliament. His house at Holcombe Rogus (see fig. 2) is widely considered one of the finest Elizabethan mansions in Devon.

PETER BLUNDELL (*c.* 1520–1601)

Born in Tiverton to a humble family, he made a fortune in the manufacture and sale of kerseys (woollen cloths). His wealth enabled him to make cash bequests in his will of £32,000 (a vast sum for the period), including £2400 to build a free grammar school in Tiverton.

JOHN BODLEY (*c.* 1520–1591)

A leading Exeter merchant and fervent Protestant, he provided funds to support Lord Russell during the Prayer Book rebellion. From 1555 he took his family (including Nicholas Hilliard) abroad to escape persecution under Mary Tudor, settling in Geneva, where he helped publish William Whittingham's and Miles Coverdale's English translation of the Bible (the Geneva Bible). Returning to London in 1559 he resumed life as a merchant and promoted the Calvinist cause.

SIR THOMAS BODLEY (1545–1613)

Son of John Bodley. Accompanied his father into exile. On return to England studied at Oxford (BA, 1563) and was Lecturer in Ancient Greek at Merton College from 1565. In the 1570s and 1580s he was sent on important diplomatic missions.

Resigned from Oxford in 1586. MP for St Germans (1586). In 1587 married Ann Ball, wealthy widow of Nicholas Ball of Totnes. Between 1598 and his death he devoted himself to equipping and restoring the library of Oxford University, which is now named after him. See fig. 27.

SIR GAWEN CAREW (c. 1484–1585)

Uncle of Sir George and Sir Peter Carew, Sir Gawen is notorious for his actions in suppressing the Prayer Book rebellion, leaving the corpses of rebel leaders hanging on gibbets from Dunster to Bath.

SIR GEORGE CAREW (c. 1504–1545)

Born in Mohun's Ottery, near Honiton, and educated in the household of Henry Courtenay, 2nd Earl of Devon and 1st Marquess of Exeter. Sir Peter Carew was his younger brother. MP (Knight of the Shire) for Devon, 1536. His military careeer began in the late 1530s, patrolling the Channel against pirates and captaining one of the English fortifications in Calais. Field commander in Flanders and France in 1543 and 1544. Took a naval command in 1545 and was promoted by Henry VIII to Vice-Admiral on 19 July 1545, at the commencement of the Battle of the Solent. The *Mary Rose* was his flagship, which foundered while manoeuvering, drowning him and all but a couple of dozen survivors of its 500-man complement. See cat. 12.

SIR PETER CAREW (1514?–1575)

The third son of Sir William Carew (c. 1483–1536). Educated at Exeter Grammar School, where he was a regular truant, then St Paul's School in London and finally at the French court. Elected MP for Tavistock 1545; Dartmouth 1547. With Sir Gawen Carew, he helped suppress the Prayer Book rebellion. In the winter of 1553–54 he was involved in the abortive plot, attributed to Thomas Wyatt, to see Princess Elizabeth marry Edward Courtenay, Earl of Devon, and replace Mary as sovereign, whose proposed marriage to Philip II alarmed Protestants. Pardoned in 1557 and thereafter served both Mary and Elizabeth faithfully. His biography was written by his friend the Exeter antiquary John Hooker.

RICHARD CAREW (1555–1620)

Born at Antony House, Torpoint. Studied at Christ Church, Oxford – where he was friends with William Camden and Philip Sidney – and the Middle Temple, before returning to Cornwall. He married Juliana, daughter of John Arundell of Trerice. Carew served as MP (Saltash 1584; Mitchell 1597), but his lasting fame derives from his learning, as a writer and translator and especially as a member of the Elizabethan Society of Antiquaries. His *Survey of Cornwall* (1602) gave detailed accounts of the landscape, people and occupations of the county. See cat. 25.

THE CHAMPERNOWNE FAMILY

The Champernownes were landowners in Modbury, related by marriage to the Carews of Mohun's Ottery. John (d. 1541) obtained the lease of St German's Priory in 1540 and his widow bought the estate from the Crown in 1541. Their son, the military commander Henry (d. 1570), sold it to John Eliot in 1565, who developed it as Port Eliot. Henry's uncle, Sir Arthur Champernowne (c. 1524–1578), brother-in-law to Richard Grenville, was a vigorous Protestant and a military commander, who, like Henry, supported the Huguenots in France. MP for Barnstaple (1547), Plympton Erle (1555), Plymouth (1559), Totnes (1563), Vice-Admiral for Devon (1563). Bought the Dartington estate in 1559.

SIR JOHN CHICHESTER (*c*.1520–1568)

Close friend of the 2nd Earl of Bedford, and with him in Italy in 1555. MP for Devon (1547, 1554, 1563) and Barnstaple (1559). Set aside £20 in his will to be spent on a tomb "for a perpetual memory".

JOHN CONYBEARE (*c*. 1550–after 1594)

Perhaps born in Tavistock. Studied at Exeter College, Oxford (1572–75). Began teaching *c*. 1576, possibly at Chittlehampton. Schoolmaster at South Molton, 1580, and at Swimbridge, 1594.

HENRY COURTENAY, 1ST MARQUESS OF EXETER (*c*. 1496–1539)

Eldest son of William Courtenay, 1st Earl of Devon, and Catherine of York, and grandson of Edward IV. He found favour at court in the 1510s and was Member of the Privy Council from 1520, Knight of the Garter 1521. Administered Duchies of Exeter, Somerset and Cornwall. Created Marquess of Exeter June 1525. Provided important services for Henry VIII but in 1538 was accused of involvement in a plot to have himself named as Henry's heir. Imprisoned in the Tower, tried at Westminster Hall and found guilty of treason, he was executed in January 1539.

PETER CROCKER (d. 1578–15888)

Slate mason, working in S.E. Cornwall. There are signed monuments by him at Talland, Lansallos and Pelynt.

LEONARD DARR (*c*.1554–1615)

Wealthy merchant of Totnes, involved in trade with Brittany, and owner of the *Crescent* of Dartmouth, which served against the Spanish in 1588 and 1589. MP for Totnes (1601). Retired to South Pool and bequeathed funds for 60 penny loaves for the poor to be laid quarterly on his tomb there "for ever". See cat. 17.

JOHN DAVIS (1543–1605)

Born near Dartmouth. The foremost navigator of his day. Lifelong friend of his neighbours Humphrey and Adrian Gilbert and Walter Ralegh. Probably educated at a grammar school (?Totnes). Made three voyages to discover the North-West Passage (1585, 1586, 1587), charted the Canadian Arctic and provided one of the earliest accounts of Inuit culture. The Davis Strait is named after him. Commanded the *Black Dog* against the Armada. Discovered Falkland Islands on Thomas Cavendish's failed circumnavigation (1591–91). Pilot to second Dutch expedition to the Indies (1598–1600). Chief pilot to first expedition of the East India Company (1601–03). Killed by Japanese pirates off Malaya.

SIR JOHN DODDRIDGE (1555–1628)

Son of a Barnstaple merchant. Educated Exeter College, Oxford, and Middle Temple. Called to the bar in 1585. Practised as judge in London and renowned for his great legal knowledge and his scholarship in general. MP for Barnstaple (1589). Lived at Mount Radford, Exeter, towards the end of his life. Served as member of the King's Council for Virginia (1606).

SIR FRANCIS DRAKE (*c*. 1540–1596)

Born Tavistock. With his second cousin Sir John Hawkins attacked the Spanish in the Caribbean 1567, 1568 and independently 1570–73. Following Elizabeth's instructions to harass Spanish interests on the Pacific coast, Drake circumnavigated the world 1577–80 in *Pelican* (renamed *Golden Hind*). Mayor of Plymouth (1581). MP for ?Camelford (1581), Bossiney (1584), Plymouth (1593). Attacked Spanish possessions in the Americas in 1585–86; attacked Spanish fleet in Cadiz in 1587. Vice-Admiral

of English fleet against Armada. Co-commander with Sir John Norris of Counter Armada (1589). With Hawkins attacked Spanish in Caribbean (1595–96), where he died of dysentery off Portobello, Panama. See figs. 15, 19.

RICHARD DRAKE (1535–1603)

A distant cousin of Francis Drake, he was the third son of John Drake of Ashe House, Musbury, near Axmouth. His mother was the daughter of Sir Roger Grenville. He was an equerry of the stable of Queen Elizabeth from 1577, a groom of the Privy Chamber in 1584 and remained high in the Queen's favour. He lived in Esher Place, Surrey, and had little to do with Devon, but in 1588 took charge of Armada prisoners captured off Plymouth. See fig. 13.

JOHN ELIOT (c. 1503–1578)

Merchant, trading at Ashburton and Plymouth. Bought St Germans Priory from Henry Champernowne (1565) and renamed it Port Eliot.

FRANCES LADY FITZWARREN (c. 1535– 1586)

In 1548 she married Sir John Bourchier, 5th Baron Fitzwarren (1529–57), son of John Bourchier, 2nd Earl of Bath (d. 1561), who married her mother, Margaret Kitson (d. 1562) in the same year. Frances's son William (1557–1623) became the 3rd Earl of Bath and rebuilt Tawstock Court in 1574. Only the gatehouse survives of the Tudor house. For her tomb see fig. 3.

ADRIAN GILBERT (c. 1541–1628)

Brother of Sir Humphrey Gilbert, half-brother of Sir Walter Ralegh, friend of John Davis. Devoted to commerce and voyages of exploration. Acquired a patent to search for the North-West Passage to China (1584). Developed a profitable silver mine (Fayes Mine) at Combe Martin (1587). Had a reputation as an alchemist, farmer and landscape gardener. Designed Sherborne Lodge and its gardens for Ralegh (1594). MP for Bridport (1597).

SIR HUMPHREY GILBERT (c. 1537–1583)

Born at Greenway, on the Dart. Nephew of Sir Arthur Champernowne. Wounded in the French wars (1563). In 1566–69 was a ruthless military commander in Ireland. MP for Plymouth (1571). Petitioned Elizabeth to back search for North-West Passage and settle colonists in North America (1565–66). In 1578 he was granted letters patent to colonize North America. At Newfoundland planted the first English colony, but drowned on return trip (1583). See fig. 22.

RALEGH GILBERT (1577–1634)

Son of Sir Humphrey Gilbert and nephew of Sir Walter Ralegh. Admiral Ralegh Gilbert was second-in-command of the Popham Colony and briefly became its leader when George Popham died in 1608, but returned to England to claim his inheritance and took the colonists with him.

MATTHEW GODWIN (c. 1569–87)

Organist and choirmaster. Worked first at Canterbury Cathedral (1584), then studied at Oxford (Bachelor of Music, 1585). Appointed to Exeter on 13 May 1586 but died within a year, aged seventeen (see fig. 7).

SIR RICHARD GRENVILLE (1542–1591)

Born at Stowe, Cornwall. His father was master of the *Mary Rose*, and drowned when she capsized in the Solent in July 1545. Studied at Inner Temple (from 1559). Served in Ireland, 1568–69. Involved in privateering venture with John Hawkins,

c. 1569. MP for Cornwall (Knight of the Shire), 1571 and 1584–86. From 1578 backed Humphrey Gilbert and then Walter Ralegh's plans for planting a colony in America, and conveyed colonists to Virginia (1585). Privateering in 1585 and 1586. Appointed deputy lieutenant with responsibility for defence of Devon and Cornwall (1587). Raided in Azores 1589. Returned there in command of *Revenge*, as Vice-Admiral under Sir Thomas Howard, to intercept the Spanish treasure fleet. Attacked 15 ships single-handedly and died 2 September 1591. See cat. 19.

HAWKINS FAMILY

The sons of Plymouth's richest merchant, William Hawkins (*c*. 1495–1554/55), were highly influential figures. By Act of Parliament (1558) Hawkins's Quay, Sutton Pool, was fixed as the only legal wharf for landing goods in Plymouth. William Hawkins (*c*. 1519–1589) was a shipowner, active in supporting the Huguenot cause and attacking Spanish possessions. Mayor of Plymouth (1567–68 and 1587–88). He financed the New Conduit for fresh water (1569–70). Fitted out seven ships and commanded one of them, the *Griffin*, to oppose Armada. His brother, Sir John Hawkins (1532–1595; fig. 21), backed by a merchant syndicate, traded slaves between west Africa and the Caribbean in 1562–63, 1564–65 and 1567–69. MP for Plymouth (1571 and 1572). From 1569–77 he performed various roles including naval duties and counter-espionage. Appointed treasurer (1577) and comptroller (1589) of the navy and improved manufacture of fighting ships. Served as Vice-Admiral against the Armada and was knighted for gallantry. With Drake, founded in 1590 the Chatham Chest to compensate disabled sailors, pay pensions, and provide burial money; funded by 5% levy on seamen's wages on royal ships. Died 12 November 1595, off Porto Rico, in the same expedition as Drake. His son, Sir Richard Hawkins (*c*. 1562–1622), sailed with his father, his uncle and with Drake in the 1580s, fought against the Armada and attacked Spanish possessions on the Pacific coast of South America (1593–94).

JOHN HAYDON (*c*.1514–1588)

Trained as a lawyer and called to the bar 1539. Attorney for city of Exeter from 1544 and legal adviser to wealthy Devon families. Active as property agent and acquired land near his home. Used stone from College of Priests in Ottery St Mary to build his new house, Cadhay Manor (*c*. 1550; see fig. 1). Simultaneously helped found new grammar school at Ottery. MP for Dunheved (1558).

LAURENCE HILLIARD (1582–1647/8)

Son of Nicholas Hilliard and Alice Brandon. Born Gutter Lane, Cheapside, London. Trained by his father. By 1606 was making miniatures and gold medals for James I and remained in office under Charles I. Only a few signed miniatures by him survive.

NICHOLAS HILLIARD (*c*.1547–1619)

Born in Exeter. Eldest son of Richard Hilliard. With family of John Bodley in Geneva (1557–59) and probably remained in his household when Bodley returned to London. Apprenticed to Robert Brandon (1562–69) and married his daughter Alice (1576). Mature works date from *c*. 1571 (see fig. 17). Spent two years in France (1576–78), where he associated with artists and intellectuals. Proficient as goldsmith, limner, jeweller, calligrapher and designer for engravings, and was the most distinguished of Elizabeth's artists, painting miniature portraits of the queen and her courtiers. Wrote treatise, 'Arte of Limning', *c*. 1600. Continued as royal limner under James I.

RICHARD HILLIARD (1518/19–1594)

Leading goldsmith of Exeter and religious reformer (see cat. 8). Took prominent role in the defence of the city in 1549, when it was besieged during the Prayer Book rebellion. Held a number of civic offices in the city.

JOHN HOOKER (c. 1527–1601)

Born Exeter. Member of Society of Antiquaries and chronicler of Exeter's history. Orphaned at ten and educated by Dr John Moreman, vicar of Menheniot. Studied at Oxford, Cologne and Strasbourg. Returned to Exeter c. 1544. Wrote an eye-witness account of siege of Exeter in 1549. Appointed as first chamberlain of Exeter in 1555, helping with financial and legal matters and improving the city by planting trees. Collected and arranged city's records. MP for Exeter (1571 and 1586). Between 1568 and 1575 worked for Sir Peter Carew to establish Carew's legal title to Irish territory. Contributed material on the histories of Parliament and of Ireland to Raphael Holinshed's *Chronicles* (1587). Commissioned first map of Exeter, engraved by Remigius Hogenberg (1587). See cat. 24.

RICHARD HOOKER (1554–1600)

Born in Heavitree, Exeter. Nephew of John Hooker. Educated at Exeter grammar school and Oxford (1569–77), where he was appointed deputy professor of Hebrew and ordained (1579). Master of the Temple in London (1585–91). Wrote *Of the Laws of Ecclesiastical Polity* (Books 1–5 published 1593, 1597) to defend the religious settlement of 1559 from Catholic and Puritan/Presbyterian criticism. From 1595 presented to the living of Bishopsbourne, Kent, where he worked on the last three books of the *Laws* (published 1648, 1662).

HURST FAMILY

Influential merchants of Exeter. William Hurst (c. 1484–1568) traded across France and Spain, was Mayor of Exeter five times and one of its MPs in 1539, 1542 and 1545. Although favouring Catholicism, he was a member of the consortium which bought former church property around Exeter on behalf of the city. His son predeceased him and his property passed to his grandson, also called William (c. 1535–95). The younger William married Mary Peter, from another wealthy merchant family, and made St Nicholas Priory into their home c. 1575–1602.

JOHN JONES (d. 1583–84)

Exeter goldsmith. Date and place of birth unknown, but working in Exeter from at least 1555. Bailiff of the city, 1567; Churchwarden at St Petrock's, 1570. His workshop next to the Broadgate was responsible for c. 150 Communion cups (see cat. 7), in addition to other items. Jones was, with Richard Hilliard, one of the wealthiest goldsmiths in Exeter. His apprentices included John Eades, Christopher Easton and William Bentley, who also produced work of very high quality.

WILLIAM KEMPE (c. 1560–1601)

Probably educated at Plymouth grammar school under William Minterne. Studied at Cambridge (BA 1580/81; MA 1584). Master of Plymouth grammar school (1581–1601). Published on the theory and practice of education: *The Education of Children in Learning* (1588) and *The Art of Arithmeticke in Whole Numbers and Fractions* (1592). Kempe was indebted to the pedagogical philosophy of Peter Ramus, fashionable at Cambridge and perhaps used by Minterne (another Cambridge graduate).

THOMAS MATHEW (1563–1611)

Barnstaple goldsmith. His work is considered to be the finest produced in north Devon and comparable with Exeter's for quality. From 1584 he was regularly chosen as a Capital Burgess in the town's Common Council, dominated by the wealthier merchants.

JOHN NORDEN (c. 1547–1625)

Born in Somerset, to a 'genteel' family. Studied at Oxford, 1564–73. Practised as a surveyor and cartographer, based in London. In 1583 proposed publishing the *Speculum Britanniae*, a description and map of every county, and in the Middlesex volume (1593) introduced to English map-making the inclusion of roads and a key to cartographic symbols. Granted the surveyorship of the Duchy of Cornwall (1605), to which he devoted most of his subsequent career. His maps (see cat. 26) were used by William Camden and John Speed and remained influential for over a hundred years.

WILLIAM PETRE (1505/06–1572)

Son of John Petre, wealthy cattle-farmer and tanner at Tor Newton in Torbryan. Studied law at Oxford (1519–26) and developed his career there. From the 1530s he was associated first with the Boleyn family and then with Thomas Cromwell, whose Proctor (assistant) he became, visiting the monastic houses of southern England to record their possessions and persuade them to surrender to the King. He profited from the Dissolution, amassing large land-holdings, and is believed to have secured 36,000 acres in Devon alone. In his later career he was very successful, holding high offices under Mary, Edward VI and Elizabeth, until his retirement.

SIR WILLIAM POLE (1561–1636)

The son of William Pole (c. 1514–1587) of Shute, near Colyton, who acquired Shute House in 1560 from William Petre and rebuilt it. The gatehouse (c. 1561-87) still survives. Pole trained as a lawyer at the Inner Temple, became Justice of the Peace for Devon by 1592, and served as High Sheriff for Devon in the year 1602–03. MP for Bossiney (1586). From at least the 1590s he devoted himself to antiquities, leaving his enquiries in manuscript on his death. Some of these were published in 1791 by John Nichols as *Collections towards a Description of the County of Devon*.

SIR WALTER RALEGH (1554–1618)

Born at Hayes Barton, near East Budleigh. His father, also called Walter, was a staunch Protestant. His mother's children from her first marriage to Otho Gilbert included Adrian and Humphrey Gilbert, who became Ralegh's half-brothers. He served in France under Henry Champernowne in support of the Huguenots (1569–70). Attended Oxford University from 1572 but left without a degree and was admitted to the Middle Temple (1575). Captain of the *Falcon* on Humphrey Gilbert's aborted exploratory voyage to America (1578–79). Soldier in Ireland, 1580–81, combatting the second Desmond rebellion. Came to Elizabeth's notice in 1581 and rose rapidly in her esteem, as courtier and poet. In 1585 he was knighted and appointed Vice-Admiral of the West, Lord Lieutenant of Cornwall, and Lord Warden of the Stannaries. MP for Devon (1584, 1586), Mitchell (1593), Cornwall (1601). Acquired property in England and Ireland and became wealthy. Organized expeditions to colonize North America, 1584–90. Assessed the defences of Devon and Cornwall against the Spanish threat (December 1587). Secret marriage in 1591 to Elizabeth (Bess) Throckmorton, one of the queen's maids of honour, saw them both briefly committed to the Tower in August 1592, but released after the capture

in the Azores of the treasure-laden *Madre de Dios* by Ralegh's fleet. Exploratory voyage to Guiana in search of El Dorado, 1595. Significant participation in naval operations against Spain at Cadiz (1596) and the Azores (1597). Intrigued against by rivals at Court, he was imprisoned for treason by James I (1603). In his 13 years in the Tower of London he wrote a number of prose works, including *The History of the World*. Released in March 1616, he planned and led another expedition to Guiana (1617) but failed to find gold or silver and by attacking Spanish settlements risked compromising the peace between England and Spain. He was executed on 29 October 1618. See cat. 15, 23.

WILLIAM RESKIMER (d. 1552)

Born in Merthen, near Constantine, he held a number of minor positions at Henry VIII's court, where his brother John (*c*. 1499–1566) also enjoyed preferment. In 1543 he was granted keepership of the ports of the Duchy of Cornwall. See cat. 13.

RIDGEWAY FAMILY

John Ridgeway (before 1517–1560) practised as a lawyer. MP for Dartmouth (1539, 1545) and Exeter (1553, 1554). He acquired half of Torre Abbey's land in 1540, on which his son Thomas (1543–98) built a new house, Torwood Manor (1579; demolished 1840). Thomas was MP for Dartmouth (1584) but was chiefly concerned with land transactions. His son, also called Thomas (*c*. 1566–1631), studied at Oxford and the Inner Temple in the 1580s and rose to become one of England's most important administrators, especially in connection with the Ulster plantation. He bought the southern portion of the Torre Abbey estate in 1598 from Edward Seymour and developed the abbey itself into an imposing family home. High Sheriff of Devon (1600), the year of his knighthood, and MP for Devon (1604–06). Created Baron Ridgeway of Gallen-Ridgeway in 1616 and Earl of Londonderry in 1622.

TRISTRAM RISDON (*c*. 1580–1640)

Born at Winscott, outside Great Torrington, he studied at Oxford but did not take a degree, having inherited the family estate on the death of his half-sister. He thereafter concentrated on the study of antiquities, completing his influential *Survey of the County of Devon* about 1632 (not published until 1714). His work is valuable for its detail, including the first narration of some of the oldest stories and legends of Devon.

SEYMOUR FAMILY

On the death of Henry VIII (1547), Edward Seymour (*c*. 1500–1552) amassed landholdings, including Berry Pomeroy Castle. He created himself Duke of Somerset and was Lord Protector of England during the minority of Edward VI, his nephew. He was responsible for putting down the Prayer Book rebellion (1549). He fell from power later the same year and was beheaded in January 1552. His eldest son, Lord Edward Seymour (*c*. 1528–1593), inherited Berry Pomeroy Castle in June 1553. He erected the new Tudor mansion inside the castle (1560–80). His son, Sir Edward Seymour, 1st Baronet (*c*. 1563–1613), was appointed deputy Vice-Admiral for Devon (1586) and was MP for Devon (1593, 1601, and 1604). He remodelled Berry Pomeroy in the most modern taste, *c*. 1600.

JOHN SHUTE (d. 1563)

He was probably born in Cullompton. Very little is known of his professional life, but he may have trained as a painter-stainer. He was sent to Italy in 1550, as a ser-vant of John Dudley, 1st Duke of Northumberland, to inspect examples of

architecture there. His book, *The First and Chief Groundes of Architecture* (see cat. 4) was published in 1563. It was the first architectural treatise in English and was also innovative for focusing on classical architecture. The engravings (woodcuts and metalcuts) were after his designs and if Shute made them he is also the first English engraver whose name is known.

NICHOLAS STONE (1586/87–1647)

Stone was the son of a quarryman at Woodbury. In London he was first apprenticed to the Dutch-born Isaac James before contracting to work in Amsterdam with Hendrik de Keyser. He returned to London in 1613 and presided over a large workshop, designing monuments and buildings (see cat. 11, fig. 27). He collaborated with Inigo Jones from about 1616 and was appointed master-mason to James I (1619) and Charles I (1626). His monument to Sir Thomas Bodley in Merton College, Oxford (1615) honours one of his Devon contemporaries.

SIR JOHN TREGONWELL (c. 1498–1565)

Probably born at Tregonnell in the parish of Manaccan, near Falmouth, and educated at Crantock College, near Newquay, he studied at Oxford from 1512 (BCL 1516, DCL 1522) and practised as a lawyer. Rewarded for assistance in divorce of Catherine of Aragon. Active in diplomacy. Contributed to the proceedings against Sir Thomas More, Anne Boleyn and the rebels of 1536. From 1535 involved in suppression of monastic establishments, especially in the South West. Acquired the Benedictine abbey of Milton Abbas, Dorset, which he had suppressed in 1539, as family home (1540). Knighted for legal services, 1553.

EDMUND TREMAYNE (c. 1525–1582)

He was the second son of Thomas Tremayne of Collacombe, Lamerton and a cousin of Sir Francis Drake. Entered the service of Edward Courtenay, Earl of Devonshire (1553), was suspected of involvement in Wyatt's rebellion and sent to the Tower and tortured (1554). Travelled in Italy, 1556–57, with Courtenay and then with 2nd Earl of Bedford. Reported on condition of Ireland (1569). Clerk of the Privy Council (1571); MP for Tavistock (1559), Plymouth (1572). Succeeded to the Collacombe estate on his brother's death (1572) and remodelled the house c. 1574.

JOHN TREW (fl. 1563–88)

A gentleman from Glamorganshire, Trew was a mineral surveyor and mining engineer. He may have had experience of copper mining in Devon, devising various pumps and lifting mechanisms, which he described in a petition to Lord Burghley. In 1563 he was engaged by the Exeter Chamber to construct a new canal, the entire scheme being completed in 1567. He worked on the Lee navigation in Essex (1578–79) and attempted to improve the mole in Dover harbour (1580–82). In 1588, describing himself as an old man, he recommended "an invention which would do as much as 5000 men in time of extremity, and also an engine to be driven before men to defend them from the shot of the enemy".

CHRISTOPER TRYCHAY (EARLY 1490S–1574)

Born in Culmstock, he did not receive a university education and was ordained in 1515. He was Vicar of Morebath from 1520 until his death. The accounts he kept of the parish from 1527 provide a uniquely detailed glimpse into the world of a small rural community during this period.

JOHN WALDRON (1520–1597)

Born in Tiverton, he became a successful clothier and merchant, exporting kerseys across Europe. He established a charity in 1577 and built a group of almshouses for eight poor people (1579–97) in his home town. Carvings of the ships he used in the trade and his staple mark are sculpted on a slab set into the almshouse chapel's exterior, as well as verses about the proper use of worldly goods.

THOMAS WESTCOTE (*c.* 1567–1637)

He was born in West Raddon, Shobrooke, near Crediton. He took part in Drake's Counter Armada (1589), with his brother George, who was killed in the assault on Lisbon. He travelled and then settled in London, before returning to Devon. Edward Bourchier, 4th Earl of Bath, persuaded him to produce a survey of Devon comparable to Carew's of Cornwall, which he completed *c.* 1630. His work was encouraged by his friends Tristram Risdon and Sir William Pole. His compilations remained in manuscript until published in 1845.

JOHN WHITE (*c.* 1540–*c.* 1593)

His origins are obscure, but his coat of arms associates him with Truro. From his knowledge and social standing it is also clear that he was a 'gentleman'. Very little is known of his life apart from the six years when he was involved in the exploration of North America (1584–90), voyaging across the Atlantic five times and governing the "Cittie of Ralegh", established on Roanoke Island in Virginia (1587). The watercolours he made of the Algonquian Indians and the flora and fauna of the New World are a remarkable survival from the period (see cat. 20–22, figs. 23, 24). He retired to Ralegh's estates in Ireland.

FURTHER READING

ARCHITECTURE

Howard, Maurice, *The Building of Elizabethan & Jacobean England*,
New Haven and London: Yale University Press, 2008

Pevsner, Nicholas, and Cherry, Bridget *Devon*,
New Haven and London: Yale University Press, 1989

Pevsner, Nicholas, and Radcliffe, Enid, *Cornwall*,
New Haven and London: Yale University Press, 1970

DECORATIVE ARTS

Ayres, James, *Domestic Interiors: The British Tradition 1500–1850*,
New Haven and London: Yale University Press, 2003

Cherry, John, *Goldsmiths*, Toronto: University of Toronto Press, 1992

Kent, Timothy, *West Country Silver Spoons and their Makers, 1550–1750*,
London: J.H. Bourdon-Smith, 1992

Wells-Cole, Anthony, *Art and Decoration in Elizabethan and
Jacobean England: The Influence of Continental Prints, 1558–1625*,
New Haven and London: Yale University Press, 1997

Yallop, H.J., *The History of the Honiton Lace Industry*,
Exeter: Exeter University Press, 1992

EXPLORATION

Andrews, Kenneth R., *Trade, Plunder, and Settlement:
Maritime Enterprise and the Genesis of the British Empire, 1480–1630*,
Cambridge: Cambridge University Press, 1984

Freeman, Ray, and Preston, Eric, *John Davis 1543–1605: The Master Navigator
From The Dart*, Dartmouth History Research Group paper 33, 2007

Gray, Todd, *Devon and the Slave Trade*, Exeter: Mint Press, 2007

Sloan, Kim, *A New World: England's First View of America*,
London: British Museum Press, 2007

Sloan, Kim (ed.), *European Visions: American Voices*,
London: British Museum Press, 2009

HISTORICAL BACKGROUND

Duffy, Eamon, *The Voices of Morebath: Reformation and Rebellion in an English
Village*, New Haven and London: Yale University Press, 2001

Gray, Todd (ed.), *Tudor and Stuart Devon: The Common Estate and Government*,
Exeter: University of Exeter Press, 1992

MacCaffrey, W.T., *Exeter, 1540–1640: The Growth of an English County Town*,
Cambridge, Mass.: Harvard University Press, 1958

Rodríguez-Salgado, M.J. (ed.), *Armada*, London: Penguin Books /
National Maritime Museum, Greenwich, 1988

Rose-Troup, Frances, *The Western Rebellion of 1549*,
London: Smith, Elder & Co., 1913

Rowse, A.L., *Tudor Cornwall: Portrait of a Society*, London: Jonathan Cape, 1941

Stoyle, Mark, *West Britons: Cornish Identity and the Early Modern British State*,
Exeter: University of Exeter Press, 2002

Whiting, Robert, *The Blind Devotion of the People: Popular Religion and the English
Reformation*, Cambridge: Cambridge University Press, 1989

LEARNING

Brayshay, Mark (ed।)., *Topographical Writers in South-West England*,
Exeter: University of Exeter Press, 1996

Broadway, Jan, *"No Historie So Meete": Gentry Culture and the Development
of Local History in Elizabethan and Early Stuart England*, Manchester:
Manchester University Press, 2006

McGrade, S. (ed.), *Richard Hooker and the Construction of Christian Community*,
Tempe, AZ: Medieval & Renaissance Texts and Studies 165, 1997

Mendyk, Stan A.E., *'Speculum Britanniae': Regional Study, Antiquarianism, and
Science in Britain to 1700*, Toronto: University of Toronto Press, 1989

Orme, Nicholas, *Education in the West of England 1066–1548*,
Exeter: University of Exeter Press, 1976

PAINTING AND SCULPTURE

Auerbach, Erna, *Nicholas Hilliard*, London: Routledge & Kegan Paul, 1961

Cooper, Tarnya, *Citizen Portrait: Portrait Painting and the Urban Elite of Tudor and
Jacobean England and Wales*, New Haven and London: Yale University Press, 2012

Edmond, Mary, *Hilliard and Oliver*, London: Robert Hale & Co., 1983

Foister, Susan, *Holbein & England*, New Haven and London:
Yale University Press, 2004

Hearn, Karen (ed.), *Dynasties: Painting in Tudor and Jacobean England 1530–1630*,
London: Tate Gallery, 1995

Hearn, Karen, *Marcus Gheeraerts II: Elizabethan Artist*,
London: Tate Publishing, 2002

Hearn, Karen, 'Elizabeth I and the Spanish Armada: A Painting and its Afterlife',
Transactions of the Royal Historical Society, 14, 2005, pp. 123–40

Hearn, Karen, *Nicholas Hilliard*, London: Unicorn Press, 2005

Llewellyn, Nigel, *Funeral Monuments in Post-Reformation England*,
Cambridge: Cambridge University Press, 2001